IMAGES
of America

BOSTON'S DOWNTOWN
MOVIE PALACES

IMAGES
of America

BOSTON'S DOWNTOWN MOVIE PALACES

Arthur Singer and Ron Goodman

ARCADIA
PUBLISHING

Published by Arcadia Publishing
Charleston, South Carolina

Printed in the United States of America

Library of Congress Control Number: 2011924716

For all general information, please contact Arcadia Publishing:
Telephone 843-853-2070
Fax 843-853-0044
E-mail sales@arcadiapublishing.com
For customer service and orders:
Toll-Free 1-888-313-2665

Visit us on the Internet at www.arcadiapublishing.com

CONTENTS

ACKNOWLEDGMENTS

Dozens of individuals and organizations contributed to this book, including architects, theater historians, libraries, and colleges. They provided images, historical facts, and stories. And they provided access not only to images and to theaters, but also to others who subsequently proved to be of great assistance. For all your help, thank you all, named and unnamed.

Contributions were made, from academic institutions, by Nancy Kelleher and Marilyn Plotkins of Suffolk University, Robert Fleming and Christina Zamon of Emerson College, Jolene Marie de Verges and Christopher Donnelly of MIT, and Paul Engle of Berklee College of Music; from venues, by Jim Jensen and Maggie Doyle of the Boston Opera House, Joe Spaulding and Anne Taylor of the Citi Center for the Performing Arts, Beth Gilligan of the Coolidge Corner Theatre, Ian Judge of the Somerville Theatre, and Bridget Carr of Symphony Hall; from the community, by Ross Cameron of Elkus Manfedi Architects, the Sack family and Terry Sack, Don Harney of the City of Boston, Rev. Stephen Fulton of the First Spiritual Temple, John Toto, A. Alan Friedberg, and Paul La Camera; from the historical community, by Kathy McLeister and Richard Sklenar of the Theatre Historical Society of America (THS), authors Michael Hauser and Donna Halper, producer of the documentary *Voices from the Basement* Mike Bavaro, and theater historians Ron Salters, Ron Newman, and Fred McLennan. Also to be acknowledged is the seminal work *The Theatres of Boston* by the late Donald C. King as well as the online resources Cinema Treasures (www.cinematreasures.org) and IMDb (www.imdb.com).

Special thanks go to Jane Winton of the print department of the Boston Public Library (BPL) for her invaluable assistance with locating and providing access to many images found in this book. These images are included Courtesy of the Trustees of the Boston Public Library, Print Department.

Special appreciation goes to Travis Haglock for extraordinary editorial assistance and to Mike Singer Media for technical support. Thanks also to friends and family who assisted, especially Barbara and David Roby, Bruce Narasin, Elizabeth Goodman, and Donna Singer.

All photographs obtained and presented from MIT are the work of photographer Nishan Bichajian.

All photographs not otherwise identified are the work of coauthor Ron Goodman.

INTRODUCTION

In 2005, a group of theater buffs from England traveled over 3,000 miles to Boston for their annual conclave. While here, they hoped to enter a shuttered movie palace hidden deep within a sprawling building at 616 Washington Street, which they had heard still existed. And it did exist, but their pilgrimage failed. The relic was the 3,231-seat Radio Keith Orpheum (RKO) Boston, but they were denied access. The following year, another group from this country was turned away as well. There is a mystique about movie palaces. These extraordinary structures, designed by great architects at enormous cost, represented an era when watching the latest films with friends, family, and total strangers was an American ritual. "The splendor of the great theaters," wrote Martin Scorsese, "was a big part of what once made movie going such a communal experience."

This book is a ticket, a ticket through time to visit these places in their heyday. It is easier than ever to access film today. But entrée to most of these theaters is impossible. This book offers such access.

Following World War I, these theaters offered inexpensive ways to experience the entertainers, the fashions, the music, and the gaiety of the Roaring Twenties. During the Great Depression, they provided escape from the worry and disappointment of everyday life—cramped apartments and workplaces, contained neighborhoods, and the noise of subway trains, sirens, and roar of trucks. And for a dollar or less, one could enter these magnificent structures like royalty, revel in the open space of the darkened auditoriums, luxuriate in comfortable seats and lounges, and be entertained by motion pictures for as long as they were able to stay.

There were other palaces in Boston—magnificent concert halls and legitimate theaters, like Symphony Hall, the Shubert, the Colonial, and the Majestic. And these all played films from time to time though that was not their usual purpose.

And there were jewels of smaller film theaters in and out of downtown, from the Modern to the Oriental in Mattapan, the Egyptian in Brighton, and the Strand in Dorchester.

It can also be said that one man's movie house was another man's movie palace. For foreign film lovers, the Exeter, the Fine Arts, and the Kenmore were fit for a king or queen. For children and comedy lovers, a visit to the LaffMovie was a trip to paradise.

Researching this book, I quickly found that it was impossible to limit it to a display of images of buildings and descriptions. Each theater had an investor, an architect, a builder, a staff, and stories. These stories were often about innovation, famous films that ran there, the stars who appeared there, various successes and struggles, and their ultimate fates, be it conversion, destruction, or restoration. So this book is also about films and film going, theater, architecture, history, the business of film, and the visionaries and pioneers who brought these places to life. It is also about the city of Boston and what life was like at the time that these theaters were active. And for many of us it is a book filled with memories.

The following is a personal memory. The Bayside Theater in Nantasket Beach (Hull), Massachusetts, was a summertime theater. It was basically an old barn with a sidewalk refreshment

stand and a flight of wooden steps that led to the second-floor lobby where tickets were bought. Inside the dimly lit auditorium were some 150 seats, a raised stage, and a small screen. Three stairs in the lobby led to the projection booth, a closet-sized room with two huge projectors and barely room for Meyer the projectionist. I was a regular attendee, hardly ever missing a new billing.

In addition, two mornings a week, I would bike to the theater to watch the ushers bring out ladders, climb up the side of the building facing the main street that also served as a primitive marquee, remove the wooden letters for the films that had just ended their three-to-four-day runs, and put up the letters for the new films about to open. They did the same for the names of the stars. Finally, bringing out posters, a pot full of glue, and a brush, they went to the opposite side of the building, opened two large glass cases, pasted over the old posters, and put up new ones marked "Now Playing" and "Coming Next."

For me, watching this twice-a-week ritual brought context to my days and great anticipation for films I was sure to see.

At the rainy afternoon matinees or the evening shows, I watched with envy as the ushers, dressed in their white shirts and blue pants with their flashlights in their pockets, took tickets and showed people to their seats. Then, they stood in back watching all these movies for free!

For years, I had thought that if I could ever get a job as an usher it would be the best thing that ever happened to me.

When I was fourteen years old, I got my first job—as an usher at the Bayside Theater.

When moving images were first seen in Boston in the 1890s, they were considered a curiosity at best. You went to peep shows or Kinetoscope parlors, paying for the privilege of looking into a box. If you were lucky, you might see a man sneezing, a couple walking toward the camera, or a shirtless wrestler showing off his muscles, with each film lasting 5 to 10 seconds.

But Thomas Edison, who had invented the Kinetoscope camera, saw great commercial promise in moving pictures. He set up a production studio, Black Maria, which began making longer and more interesting short films, like Buffalo Bill shooting, US president McKinley walking outside the White House, and Edison's milestone film short—a couple kissing. He bought the rights to a system that would project these images onto a wall or small screen so that many people could sit together and watch. Peep shows and parlors quickly gave way to what were called nickelodeons— often storefronts, sometimes rented for the day or week, some with chairs and some without. The first such storefront in Boston was Austin's Nickelodeon. It was also the first storefront in the country to use that word in its name. Many served beer and were often raucous places frequented by schoolboys, men stopping off after work, and local bar types.

Yet right outside that darkened room was a bustling city filled with theaters, concert halls, and dozens of auditoriums, churches, and other venues dedicated to presenting entertainment and the arts. As one of the country's largest cities, Boston was known as a center for culture. It was a regular stop for touring acting companies and famous American and European actors, actresses, musicians, and entertainers.

The city drew young people from other parts of the country who sought to learn useful trades, to connect with the growing entertainment industry, or simply to gain meaningful employment. So it was no surprise that a B.F. Keith or an Edward Albee would seek their fortunes in Boston. As the 20th century unfolded, interest in film increased dramatically, as did film production. Up-and-coming theater architects built some of the finest early movie theaters here. Early on, Boston was known as a city where individuals interested in film production, distribution, and exhibition could connect with like-minded people for advice and possible partnerships, among them being Louis B. Mayer, Adolph Zukor, and Marcus Loew, all of whom went on to become film industry leaders.

Film was becoming big business in Boston.

—Arthur Singer

One

ALWAYS A
THEATER TOWN

When moving pictures first came to Boston in the form of a short series of flip cards of photographs that gave the appearance of movement, they were looked on as a minor curiosity. By that time, the 1870s, the city was already overflowing with a great variety of entertainment presentations shown in theaters, museums, and concert halls. And it did not cost much to see jugglers, musicians, actors, animal shows, and circuses.

From the beginning, Boston audiences were demanding, passionate, and political as well. In early years, if a song or play seemed to favor the British or French, fights would break out between Federalists and Republican sympathizers. In 1796, at a performance of the play *Poor Soldier*, a riot ensued with patrons destroying benches, doors, and windows.

This kind of behavior kept many women away from early theaters. But by the early 1800s, resident theater groups, along with the finest musicians, singers, actors, and actresses from Europe and across the country, were appearing regularly here. With the arrival of the Music Hall in 1852 and the founding of the Boston Symphony Orchestra, the Boston Pops, and the New England Conservatory in that hall, Boston established itself as a world-class cultural center.

With the arrival of B.F. Keith, Boston also became a trendsetter for another kind of popular entertainment—vaudeville.

Moving pictures would have to get a lot more entertaining and sophisticated to compete.

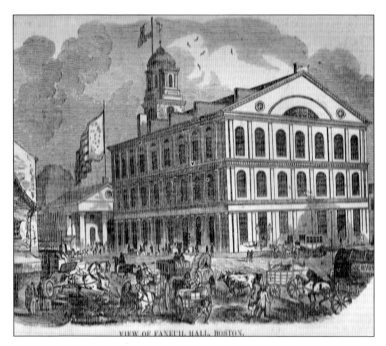

BOSTON'S FIRST THEATER. Though Pilgrims frowned on theater as an "extravagance" and Massachusetts passed an act in 1750 prohibiting stage plays and theatrical entertainments, demand grew by the year. When the British began their occupation in 1775, Gen. John Burgoyne converted Faneuil Hall into a theater, and his soldiers produced and acted in plays open to the public. (Courtesy of BPL Print Department.)

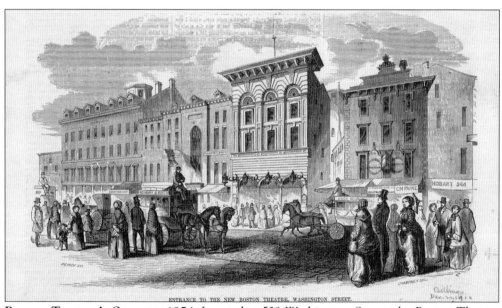

BOSTON THEATRE'S OPENING, 1854. Located at 539 Washington Street, the Boston Theatre was among the largest theaters in the country at the time. Its huge auditorium included three balconies and seated 3,140 people. It presented operas, ballets, concerts, and dramas. Many international stars performed here, including Edwin Booth and John Barrymore. Later purchased by Keith, it proved too large for vaudeville and film and was demolished in 1927. (Courtesy of BPL Print Department.)

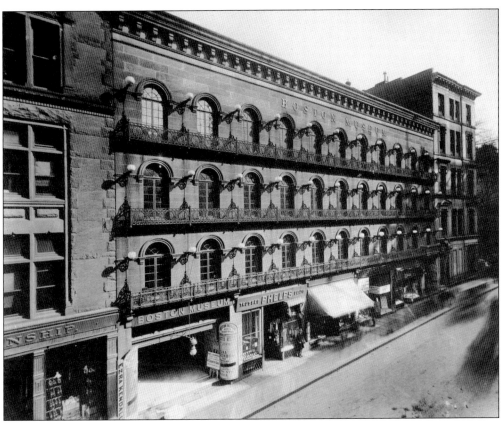

BOSTON MUSEUM, 1846. Museums were another major source of public education and amusement. In Boston, the enterprising director Moses Kimball combined collections and exhibits with varying music and comedy presentations, often trading acts with New York's P.T. Barnum. His second Tremont Street building, near King's Chapel, featured a 1,500-seat auditorium. Another venue for theater and later film was the nearby Tremont Temple. (Courtesy of BPL Print Department.)

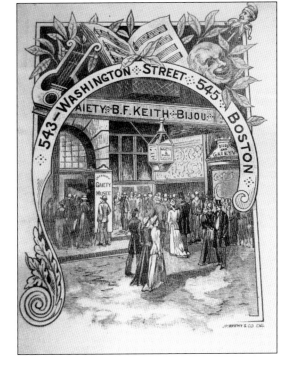

HISTORIC BIJOU THEATRE OPENS, 1882. Located next to the Boston Theatre, the Bijou was built out of the shell of two previous structures at 545 Washington Street. It played a major role in the history of theater, vaudeville, and film. In 1908, after renovations, Keith reopened it as the Bijou Dream, showing continuous motion pictures. (Courtesy of BPL Print Department.)

11

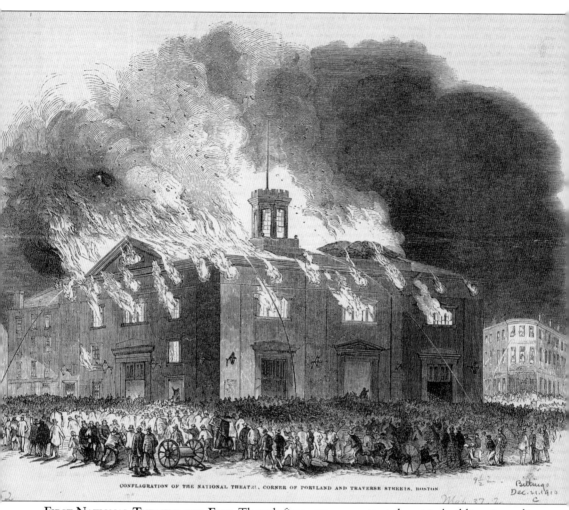

CONFLAGRATION OF THE NATIONAL THEATRE, CORNER OF PORTLAND AND TRAVERSE STREETS, BOSTON

FIRST NATIONAL THEATRE AND FIRE. Though fires were a constant threat to buildings in earlier times because of the extensive use of wood during construction, there was still a particular sense of loss when a theater was destroyed. Bostonians have always valued not only performances but also the places where they have gathered to experience them. In the 1800s, two Globe theaters, two National Theatres, and three Tremont Temples were destroyed by fire. In each case, funding was found, and they were quickly rebuilt. In this illustration, the destruction of the first National Theatre in 1852 is pictured. Its successor, built in just seven months, burned to the ground 11 years later. In recent times, Bostonians have been troubled less by the threat of fire than by that of demolition. To theater lovers, no theater deserves that fate. (Courtesy of BPL Print Department.)

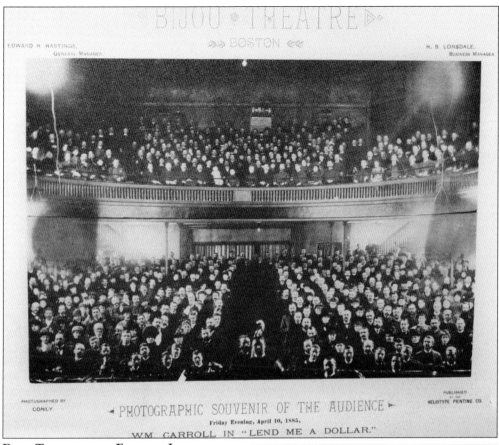

BIJOU THEATRE

BOSTON

EDWARD H. HASTINGS, GENERAL MANAGER.

H. B. LONSDALE, BUSINESS MANAGER.

PHOTOGRAPHED BY CONLY

PUBLISHED BY THE HELIOTYPE PRINTING CO.

◄ PHOTOGRAPHIC SOUVENIR OF THE AUDIENCE ►

Friday Evening, April 10, 1885.

WM. CARROLL IN "LEND ME A DOLLAR."

FIRST THEATER WITH ELECTRIC LIGHTS, 1882. Under the direct supervision of Thomas Edison, the Bijou made theater history when it converted its stage lighting from calcium gas to the safer and softer electricity. It was one of many safety features, like large skylights that could be opened in case of fire. The Bijou also had 13 exits and, as this photograph shows, greatly pleased Boston theatergoers. (Courtesy of BPL Print Department.)

BENJAMIN FRANKLIN KEITH, INVENTOR OF VAUDEVILLE. Born in New Hampshire, Keith ran away from home at seven and worked on a farm until he was 18 years old, when he left to join a traveling circus. Impressed, he headed to New York, working at Bunnell's Museum and then with P.T. Barnum before going out on his own. (Courtesy of *Boston Herald*.)

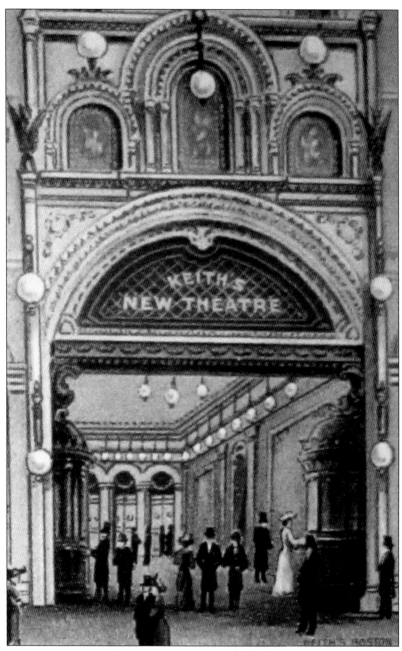

MOTHERHOUSE OF AMERICAN VAUDEVILLE, 1894. With the unprecedented success of the Bijou, Keith and old friend Edward F. Albee bought the building next door and replaced it with a much larger and more elegant theater for his form of family-friendly vaudeville. With a modest entrance on Washington Street, B.F. Keith's New Theatre stretched back to Mason Street and beyond. In the years that followed, almost 400 such theaters were built across the country. Keith hired New York architect J.B. Melfatrick to build it, and they spared no expense. Four stories high, the first lobby featured marble floors, elaborate wall designs, and a painted dome. A second lobby contained a grand staircase that took ticket holders up to the auditorium level. Electric lamps lit the way, along with nymphs, cupids, and cherubs. (Courtesy of BPL Print Department.)

NEW THEATRE STREET SCENE. In this early photograph is the arched entrance to Keith's New Theatre in its actual setting and scale. Because property owners were taxed in part on the amount of real estate they had bordering Washington Street, theaters along the street tended to have modest entrances, not revealing the extent of the auditoriums just beyond. (Courtesy of *Boston Herald*.)

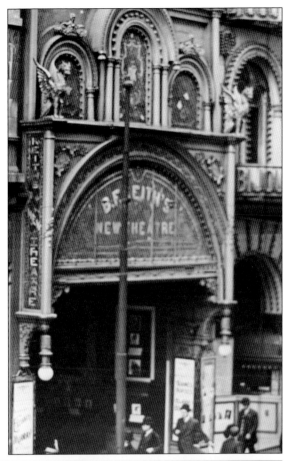

NEW THEATRE PROMOTION. To remind downtown workers and shoppers of the great shows awaiting them at the New Theatre, Keith secured a carriage, four horses, and two footmen to roam the downtown streets during the day. This photograph shows a replica ordered up by Edward Albee in 1928 for promotional use during the opening of the new RKO Keith Memorial theater, the entrance to which is in the background. (Courtesy of *Boston Herald*.)

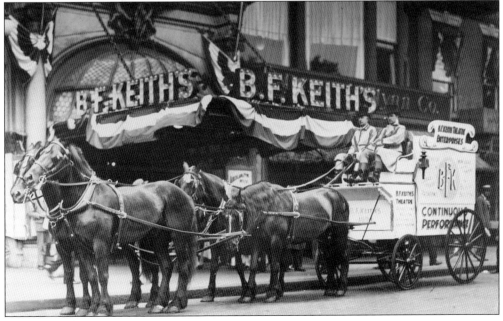

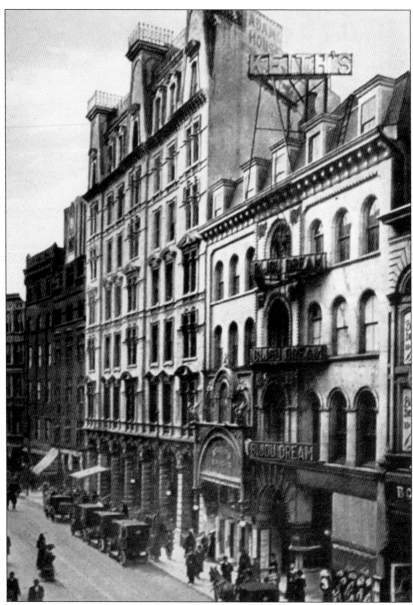

THREE THEATERS IN A ROW. This photograph is looking south on Washington Street. The Keith's sign tops the four-story building also containing the New Theatre and the Bijou Dream. The living quarters for the Keiths may have been where the dormers are located. The New Theatre's arched entrance also provided access to the Bijou Dream. In 1908, Keith and Albee had added a third theater to their complex, the venerable Boston Theatre, just to the right. The Boston had tried valiantly to compete with the increasing number of vaudeville houses in town but had failed. Keith's circuit and William Morris's new circuit had a stranglehold on the top acts. When Morris leased the nearby Music Hall, the city became the center of their fierce battle to control vaudeville bookings not only here but also nationally. By purchasing the Boston, Keith was able to eliminate a local competitor. Shortly afterward, he decided to drop the Boston's vaudeville program altogether and began leasing it out for legitimate stage productions. The entire three-theater complex accommodated 6,000 people. (Courtesy of BPL Print Department.)

TREMONT STREET ENTRANCE. Three years later, while Boston's first-in-the-nation subway was being built under busy Tremont Street, Keith added a Tremont Street entrance. His famous Crystal Tunnel received national attention and helped create a new image for vaudeville as more than crass entertainment for the masses. (Courtesy of BPL Print Department.)

CLOSE-UP OF ENTRANCE. In this photograph, passersby are noticing the entrance. Later, when the RKO Keith Memorial was built, this same entrance, through the Crystal Tunnel, led to that theater as well. This was eventually closed to make way for new buildings and apartment complexes. (Courtesy of BPL Print Department.)

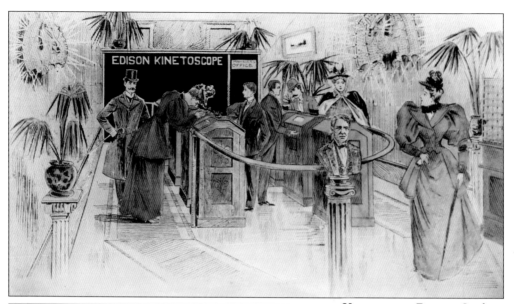

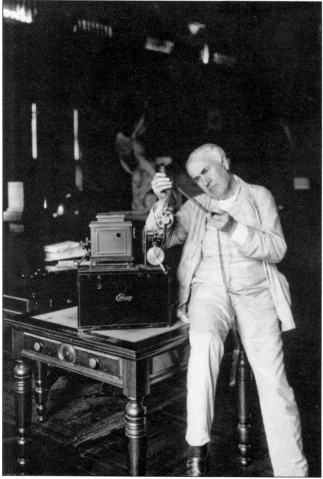

KINETOSCOPE PARLOR. In the 1890s, after Edison's company came up with the Kinetoscope camera, machines were developed for viewing the films in locations like this one in New York City and soon Boston. These machines were set up in rows with each showing a different moving picture short. Films ran only a few minutes, and each person watched separately. (Courtesy of Thomas Edison National Historical Park.)

EDISON EXAMINES FILM STRIP. Later, after Edison's labs produced a system for projecting films, nickelodeons opened, showing one-reel films on walls or screens. Keith took notice, and Edison's early Vitascope, which projected motion pictures, made its first Boston appearance at the New Theatre, showing three times a day along with vaudeville. (Courtesy of Thomas Edison National Historical Park.)

Two

WASHINGTON STREET, BOSTON'S BROADWAY

The history of Boston movie theaters is inexorably tied to a seven-block stretch of a narrow one-way street that meanders through the most historic part of downtown Boston. Running from Winter Street to Essex Street, this crowded, constantly evolving thoroughfare with its short side streets was, between 1852 and 1950, Boston's main entertainment center. First came the Music Hall, then the huge Boston Theatre, and, in rapid succession, playhouses, dime museums, nickelodeons, vaudeville and burlesque houses, and movie theaters and palaces. Eateries, bars, and hotels followed. By the turn of the century, there were more than 50 theaters in Boston. And by 1915, approximately 20 of them were located on this quarter-mile stretch alone.

To walk these blocks is to walk in the steps of B.F. Keith, Edward Albee, Louis B. Mayer, Marcus Loew, E.M. Loew (no relation), Joseph P. Kennedy, Jacob Lourie, Nathan Gordon, and others who made the movies what they are today.

Everyone knew Washington Street. People from all over New England would travel here for business or pleasure. For many years, it was also the heart of Boston's shopping district, with legendary department stores, like Jordan Marsh, Filene's, Gilchrist's, R.H. Stearns, Kennedy's, R.H. White's, and Raymond's. Just to the north was Newspaper Row, and to the east was the downtown business district. Even before the era of automobiles, Boston's transportation system allowed easy access to Washington Street.

Arriving on Washington Street at any time of year, day or night, was a treat for the eyes, ears, and other senses. Entering theaters took only a few seconds, and at that point, one was transported to a world of make-believe. From the structures themselves to the films they showed, one left, as the song goes, his or her worries behind.

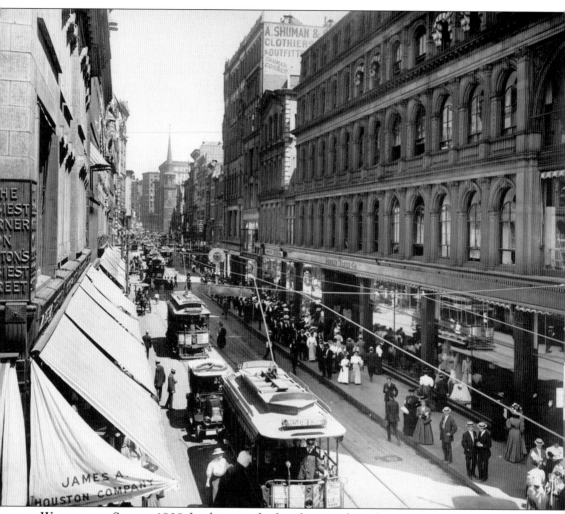

WASHINGTON STREET, 1908. Looking north, this photograph is of a quiet August weekday in the heart of Boston's shopping district at Temple Place. Jordan Marsh's original store is visible (right). Beyond are Newspaper Row (the home to several Boston dailies), the old state house, and Scollay Square. Houston & Henderson's dry goods store is visible at left, and just beyond is Winter Street, with the vertical sign for the newly renamed Orpheum. Many of these buildings housed shops and offices on the upper floors. Just south, the theater district begins, with new houses springing up regularly, block after block. Vaudeville and nickelodeons had become more respectable, and customers could arrive and depart easily by trolley. One-reel films that year included 16-minute versions of *Romeo and Juliet*, *Macbeth*, and D.W. Griffith's first film, *The Taming of the Shrew*. (Courtesy of Boston Photo Imaging.)

WASHINGTON STREET, FARTHER SOUTH. Trolleys were still running above ground on two-way Washington Street when a visitor from Argentina mailed this postcard home. The building with the arched front entrance (left) is B.F. Keith's, with the Bijou Dream and the second Boston Theatre just beyond. Traveling into town on public transportation was convenient and inexpensive. (Courtesy of BPL Print Department.)

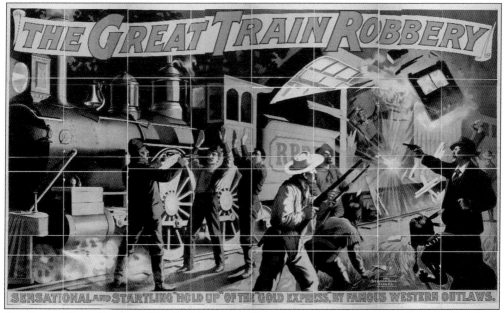

THE GREAT TRAIN ROBBERY. This slightly worn collector's poster commemorates the groundbreaking silent film. Directed by Edwin Stanton Porter, one of Edison's projectionists who became a master of short-film storytelling, the film depicts a group of bandits who stage a brazen train holdup. One of the first films to use crosscutting to create tension, it ran 11 minutes and was an audience favorite for years. (Courtesy of Emerson College.)

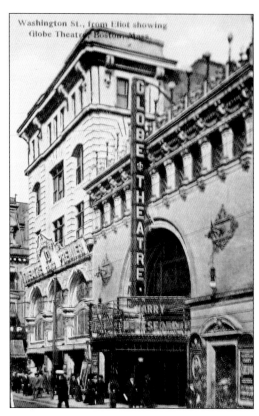

Washington St., from Eliot showing Globe Theatre, Boston, Mass.

THE GLOBE AND NEIGHBOR. Built as a legitimate theater on lower Washington Street in 1903, the 1,536-seat Globe soon added vaudeville, joining the Marcus Loew circuit in 1912. Eddie Cantor, Fanny Brice, and Abbott and Costello all appeared on its stage. Above its graceful arched entrance, the brightly lit marquee was visible far up the street at night. On its left, the 250-seat Theatre Premier arrived in 1907. (Courtesy of BPL Print Department.)

THE BUILDING TODAY. After a second career as the Center, E.M. Loew's flagship theater, it became the Pagoda, a first-run Chinese language cinema. But that too ran its course, and the theater's entrance was converted to a busy market with the popular Pagoda Restaurant above. In the dining room, one can still admire the theater's grand arched ceiling and other original features.

GORDON'S OLYMPIA. Built by Maurice Gordon, with Clarence Blackall as architect, the Olympia opened just a block north of the Globe on May 6, 1912, at the height of Boston's theater building boom. Though its facade towered above other area buildings, the theater itself was of moderate size, seating 1,500. Note the vertical sign in the center of the facade. The distinctive arch would be repeated the next year in Scollay Square. Like many in the business at that time, Gordon began as part owner of a penny arcade. He eventually owned 38 New England theaters, including Worcester's first and a giant in Cambridge's Central Square. Blackall was Boston's most prolific and versatile architect. Besides some 20 Boston stage and film houses, he designed many Boston landmarks, including the Copley Plaza Hotel and the Little Building. (Courtesy of John Toto.)

THE HISTORIC GAIETY. Across from the Globe, this singular theater opened in 1908. Operated as part of the Columbia "clean burlesque" circuit, it claimed as its biggest stars the comedy team of Bobby Clark, with his painted-on glasses, and Paul McCullough. During the 1920s, the Gaiety was especially known for its Big Black and White integrated shows, which were produced for integrated audiences, making the Gaiety unique among Boston theaters. (Courtesy of Emerson College.)

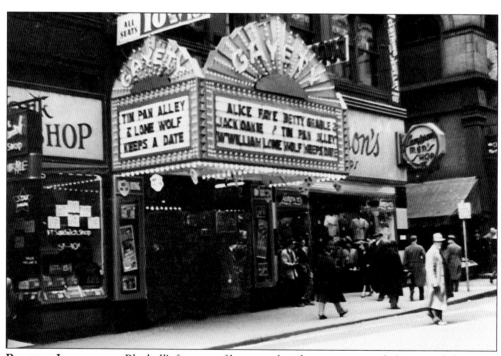

PLACE OF INNOVATIVE. Blackall's first use of large steel girders to support a balcony and eliminate columns was at the Gaiety. Purchased in 1931 by E.M. Loew primarily for movies, it featured live entertainment through World War II. Later renamed the Publix, it closed in 1980 and fell into major disrepair. A long citizen effort for preservation status failed, and it was torn down in the spring of 2005. (Courtesy of BPL Print Department.)

MAYER'S BOSTON DAYS. As a young man working in Boston, the future film giant was fascinated by nickelodeons. He showed good ownership, management, and promotional abilities with the Gem and the Colonial in Haverhill. He then got into distribution and production, moving from Brookline to California. In 1924, Marcus Loew purchased Mayer's studio, merged it with two others, and founded Metro-Goldwyn-Mayer, naming Mayer as head. Mayer remained the genius behind MGM for 27 years. (Courtesy of *Boston Herald*.)

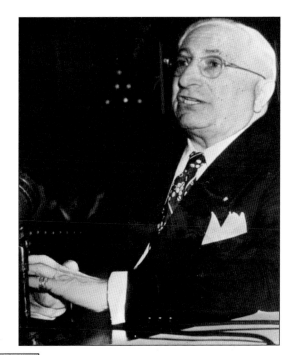

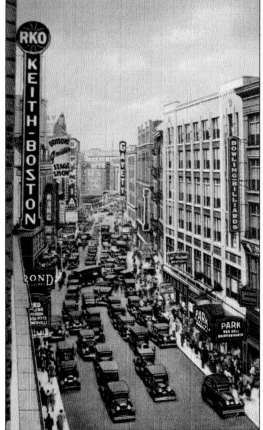

WASHINGTON STREET LOOKING SOUTH, 1933. This vintage postcard is looking south from Hayward Place. The 1925 Keith-Albee Boston theater, now owned by RKO, is on the left. The marquee headlines its stage show star and a film with comic actress Zasu Pitts. Farther down on the left is the Olympia Theater, and off in the distance, the Globe. Across the street is the legendary Gaiety, and in the foreground, the Park Theatre, which is running a new Rex Reed western. (Courtesy of Suffolk University.)

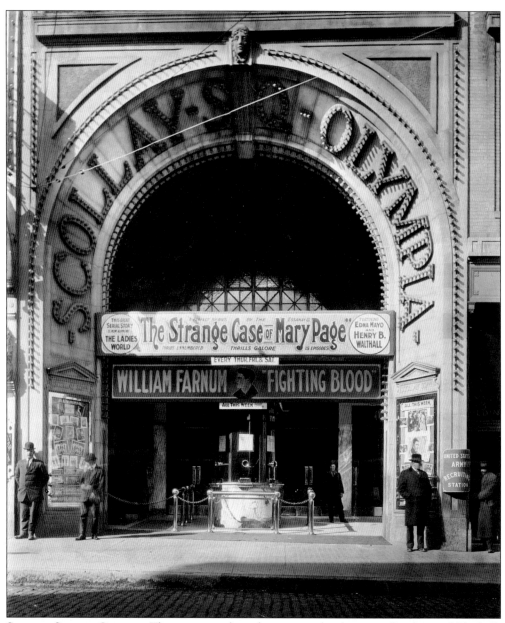

SCOLLAY SQUARE OLYMPIA. The creation of another partnership between Gordon and Blackall, the second Gordon theater was also defined by its arched entrance. It was much larger than the Washington Street Olympia, seating 2,438. It opened as a vaudeville house in 1913. Milton Berle, Weber and Fields, Fanny Brice, Boston's own Fred Allen, the Marx Brothers, and George Burns often played here and elsewhere around town. When vaudeville faded, the Olympia turned to film. This particular week, the lower sign heralds Boston-born matinee idol William Farnum. The upper banner highlights another episode of the 16-part *Mary Page* crime serial. Serials were a staple of film for 50 years. As for the talented Blackall, he had earlier been the architect for the Old Howard Atheneum, the Tremont Temple, the Gaiety, the elegant Colonial, and the Wilbur and would continue to build more theaters in the city. (Courtesy of the Bostonian Society.)

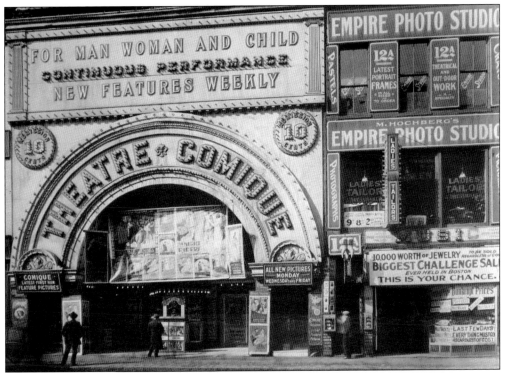

COMIQUE, 1906. The first theater built in Boston exclusively for film, the Theatre Comique, was on Tremont Row in Scollay Square. Unlike more rough-and-tumble nickelodeons, its half-hour programs featured short films and illustrated songs for a dime. Four months later, the 250-seat Unique opened on Washington Street with the same combination. (Courtesy of BPL Print Department.)

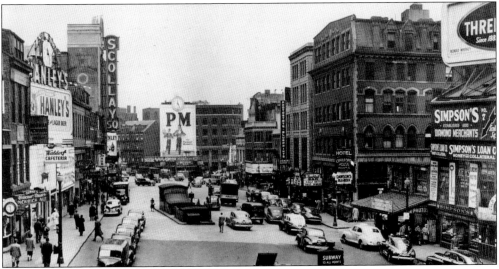

HOME TO FIVE FILM HOUSES. Located just north of Washington and Tremont Streets, once prestigious Scollay Square became known for its bars, tattoo parlors, and burlesque houses. Here is a view looking up Cambridge Street toward downtown. The Rialto and Olympia are visible on the far left, and the Strand is under the Crawford House sign. In the 1950s, all of Scollay Square was demolished to make way for Government Center. (Courtesy of BPL Print Department.)

ANOTHER LOST THEATER. Opened in 1910 by theater pioneer Jacob Lourie, this 700 seater on upper Tremont Street showed short films, vaudeville, and later full-length features. Acquired in the early 1950s by businessman Ben Sack, the Beacon Theatre became one of Boston's few art houses. Its most famous booking was Bridget Bardot's *And God Created Woman*. Another Government Center casualty, it was later replaced with the Beacon Hill Cinemas. (Courtesy of BPL Print Department.)

EARLY NICKELODEON. Built just a few years after the elevated transit system, the Puritan opened as a nickelodeon in 1905, located on Washington Street near Massachusetts Avenue. Looking down from the train platform in 1956, it is difficult to see the busy business area below. Operated by E.M. Loew, it remained a neighborhood favorite well into the 1960s. This week's attraction is a Western romance that featured Tab Hunter and Natalie Wood. (Courtesy of MIT, Rotch Visual Collections.)

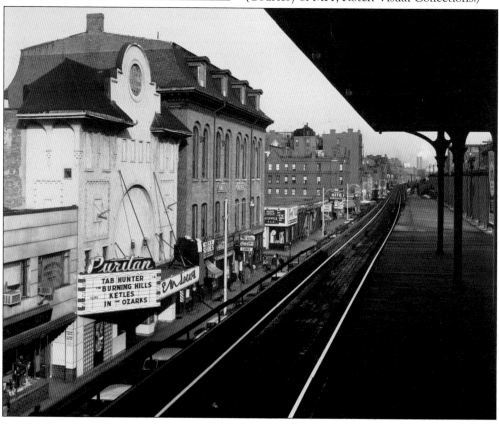

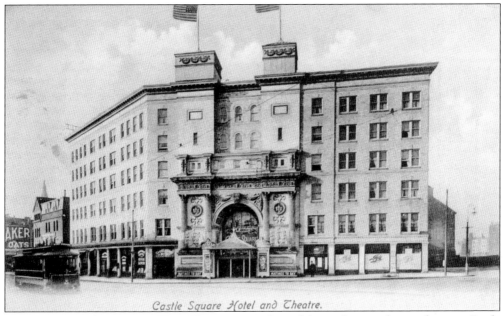

Castle Square Hotel and Theatre.

CASTLE SQUARE OPENS WITH HIGH HOPES, 1894. One of the city's most elegant theaters, Castle Square was on Tremont Street in the South End, just beyond downtown. Built into the facade of a new hotel, its auditorium occupied the unfinished circular space originally intended for a huge cycloramic painting. The six-story arched entrance led one national critic to call it "one of the finest, most elaborately furnished buildings devoted to theatre." (Courtesy of BPL Print Department.)

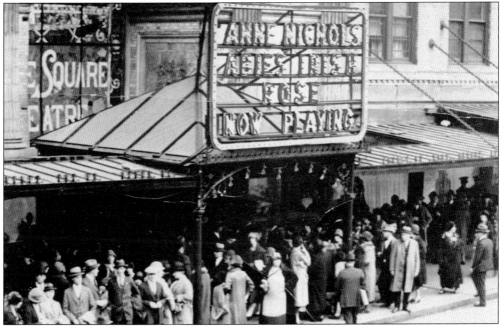

CROWDS LINE UP AT THE CASTLE SQUARE, 1928. Here is the theater showing the immensely popular late silent film *Abie's Irish Rose* with Buddy Rogers. But with the Great Depression coming on, overall attendance dropped off, and the theater was demolished just four years later. (Courtesy of BPL Print Department.)

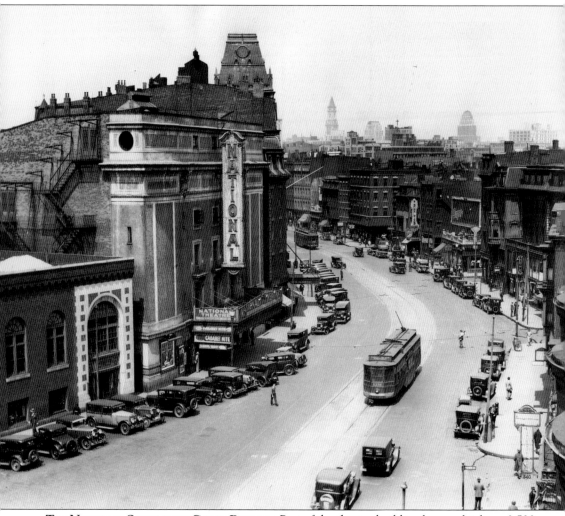

The National Opens with Great Promise. Part of the theater building boom, this huge 3,500-seat South End house opened in September 1911 with an estimated 8,000 people clamoring to get in. On Tremont Street, not far from downtown, the vaudeville and stage show house was just a few blocks from the Castle Square Theatre and next to the storied Cyclorama Building. Despite its early popularity and easy access via streetcar, the one thing the National could not offer customers was the excitement of being downtown amidst restaurants, bars, and clubs. Soon many residents were moving to the new Back Bay area, and within a decade, the neighborhood was overrun with tenements and boardinghouses. Yet the National managed to survive many years as a local second-run film house. Ironically, it was demolished just as the area re-gentrified. The Calderwood Pavilion now stands on the site. (Courtesy of BPL Print Department.)

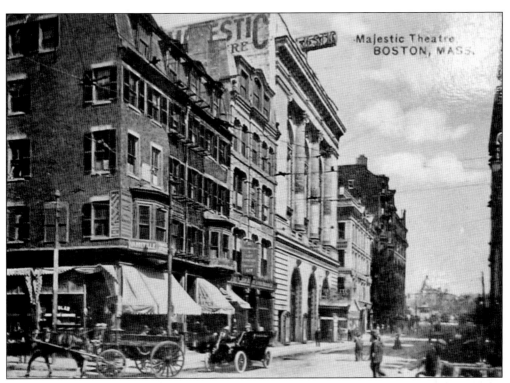

MAJESTIC OPENS, FEBRUARY 1903. A Boston treasure designed by John Galen Howard and built on Tremont Street, near Stuart Street, the legendary Majestic opened to rave reviews. Through the years, it ran many shows headed for Broadway, including Gershwin's *Of Thee I Sing*. This postcard looks north along Tremont Street to the Boston Common and the state house. In time, six theaters would be operating within a two-block area. (Courtesy of BPL Print Department.)

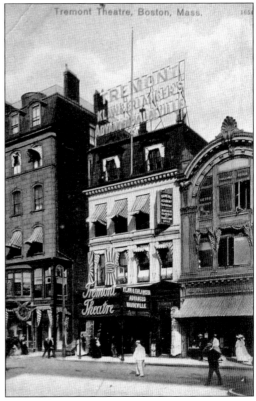

TREMONT STREET FAVORITE. For 25 years, the 1,700-seat Tremont Theatre at the corner of Avery was home to live theater and opera. In 1915, it became a film house and succeeded in the business until the Depression. With attendance hurting, it switched to double features of rereleases. Rereleased films were a novelty in the days when most films disappeared after a month or two. (Courtesy of BPL Print Department.)

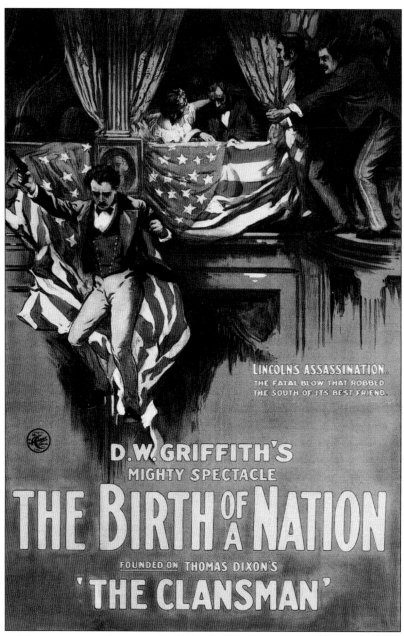

BIRTH OF A NATION AT THE TREMONT. In 1915, the Tremont acquired D.W. Griffith's *Birth of a Nation* from young local distributor Louis B. Mayer. The three-hour film was revolutionary in its presentation of Civil War battles and the Lincoln assassination. It was also tremendously controversial, portraying a ravaged postwar South saved in large measure by the Ku Klux Klan. On opening day, a riot ensued on Boston Common. All these factors contributed to extraordinary public interest. The film played to capacity audiences for months, helping establish feature films as a legitimate art form. The 62-year-old theater was reincarnated in 1947 as the Astor. It is best remembered for exclusive first-run engagements, including *The Best Years of Our Lives*, *Hans Christian Anderson*, and *The Ten Commandments*. Closed in 1972, it was replaced by the AMC Loew's Multiplex. (Courtesy of Arthur Singer.)

Three

THE MODERN THEATRE

The year was 1914, and Jacob Lourie was about to open his second theater. His first, the 800-seat Beacon, had opened in 1910, located on Tremont Street at the edge of Scollay Square. It offered short films and vaudeville and was doing well. But the public's appetite for film kept increasing, and Lourie decided the time was ripe to invest in a second theater. He bought and converted the Dobson Building on Washington Street, just a few doors down from the Boston Theatre (which featured plays and concerts), the tiny Bijou, and B.F. Keith's vaudeville house.

His timing was perfect. Beginning in 1912, movies of five reels or more were perfected and became available in the United States. Running up to 90 minutes each, these "feature films," like stage plays, allowed the telling of complete stories and were an immediate hit with audiences. For Paramount and other companies to distribute more features each year, more theaters dedicated entirely to film were needed. Lourie's model fit the bill perfectly.

In the years that followed, Lourie continued to be a trendsetter. When Marcus Loew, who had bought the Music Hall and turned it into the Orpheum vaudeville house, was dissatisfied with his revenues, he decided to add feature films to the programs. That gave Lourie a powerful new competitor in town for first-run feature film product. In response, Lourie invented the double feature, his theaters showing two feature films for the price of one. Theater owners across the country followed suit, and for the next 40 years, double features were an industry standard for houses large and small.

When the technology for showing true talking pictures became available, in other words not just silent films synced to phonograph records, Lourie installed the first such system at the Modern, the first in the country. Soon after, the Modern was the choice of Warner Bros. Pictures to open the first official talkie, *The Jazz Singer*, in Boston.

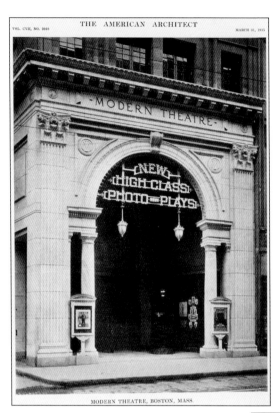

MODERN THEATRE, BOSTON, MASS.

MODERN THEATRE ENTRANCE, 1914.
With its two-story, white, Vermont-marble facade in the form of a triumphal arch, the Modern opened to high praise for its design and special features. Architect Blackall had previously designed the Wilbur and Colonial theaters and the Copley Plaza hotel. Yet, here was a small theater for which he provided arguably the most impressive entrance in Boston. (Courtesy of Suffolk University.)

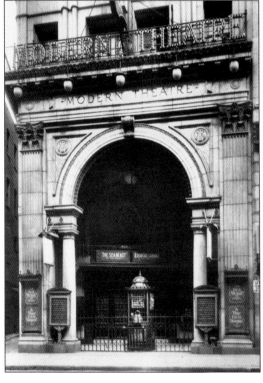

MODERN THEATRE ENTRANCE, 1926. In this photograph, taken 12 years after the opening, a lighted sign has been added. The current film, *The Sea Beast* starring John Barrymore, was produced by Warner Bros. and included sea scenes filmed on a California lake. By now, Lourie had a long-term contract with Warner Bros. for first-run rights in Boston, an agreement that would soon pay big dividends. (Courtesy of Suffolk University.)

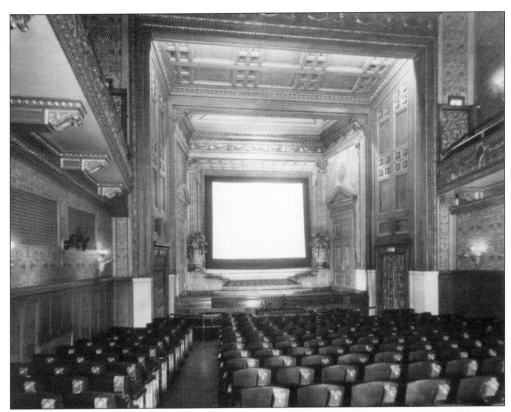

ORCHESTRA VIEW OF SCREEN. Intimate in size and designed for film only, the stage was tiny. Musicians sometimes performed music for the silent films while sitting in the first row. And housed in a console in front of the stage was the first Estey 3/38 organ, which was built especially for movie theaters. Note the sloping floor guaranteeing a perfect view from any seat. (Courtesy of John Toto.)

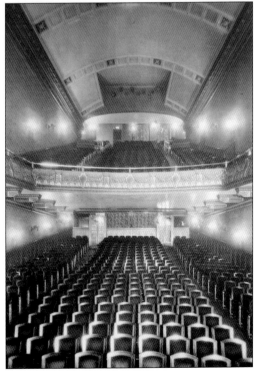

ORCHESTRA AND BALCONY FROM STAGE. Seating 800, the Modern offered a sense of intimacy between the film and the viewer, unlike the bigger vaudeville houses that had added film. A good double feature would fill every seat, adding to the feeling of being at something special. The theater had near-perfect acoustics, having been designed by the founder of architectural acoustics, Wallace Sabine. (Courtesy of John Toto.)

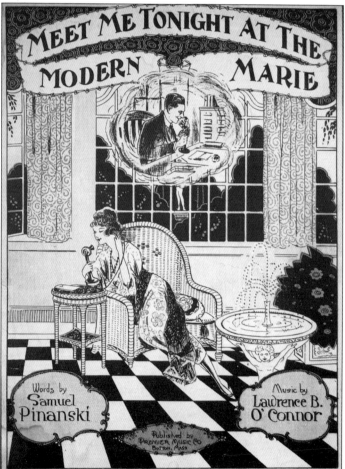

TWIN THEATERS BLOCKS APART. Duplexes and multiplexes were decades away, but Lourie usually offered the same bill at both his theaters and was successful in spite of their proximity. One advantage was the ability to transport reels from one venue to the other by streetcar between showings. Joint newspaper advertisements and card promotions saved money as well. (Courtesy of John Toto.)

SHEET MUSIC GIFT. In honor of the new theater, two of Lourie's close business associates, Samuel Pinanski and Lawrence B. O'Connor, created this song for voice and piano and made it available for sale in music stores of the day. (Courtesy of John Toto.)

PIONEER, INNOVATOR, LEADER. As a pioneer and innovator, Lourie is remembered for many firsts, including his installing the first permanent sound equipment system and his converting from hand-cranked to electric projectors. As a leader, he founded the New England Theatres Operating Company (NETOCO). (Courtesy of John Toto.)

GATHERING OF NEW ENGLAND THEATER OWNERS AND OPERATORS. In the early years, theater exhibitors had little bargaining power with studios regarding film prices, and when distributors came along, the problem was only exacerbated. Believing in strength in numbers, Lourie (first row, fifth from right) and Pinanski convinced theater owners that they would have more clout working together than apart. (Courtesy of John Toto.)

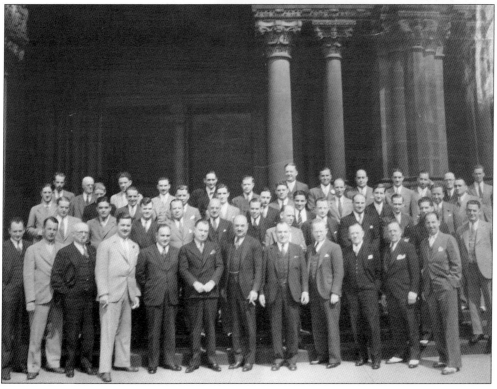

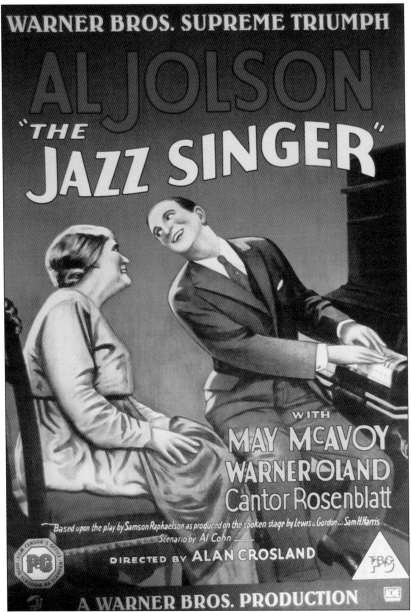

TALKING PICTURES PREMIERE. When *The Jazz Singer* opened in New York City on October 6, 1927, it changed the movie business forever. Using the relatively new Vitaphone sound-on-disc system, Warner Bros. had decided the time had come to apply the process to a feature-length film. Its leader, Sam Warner, chose the script of a son who rejects his family's traditions and heritage and leaves home to pursue a career as a jazz singer. Then he convinced national vaudeville favorite Al Jolson to star in what was to become the first talkie. Though only the musical sequences and a few lines of dialogue were included, public reaction was extraordinary. The Modern was the only theater in Boston permanently equipped with the Vitaphone system thanks to Lourie's good judgment and foresight. Lourie had also developed a close relationship with Warner Bros., which chose the Modern for the first Boston run. The film ran for many weeks, setting box office records. (Courtesy of Arthur Singer.)

Success, Decline, and Revival. The Modern later introduced the double feature in an effort to compete with newer theaters showing movies and vaudeville together. Theaters across the country adopted the new concept. The Modern (later the Mayflower) remained in business until the 1980s and was then shuttered for 30 years. Included in the National Register of Historic Places in 1979, it was designated a Boston Landmark in 1995. Suffolk University soon embraced the idea of restoring the Modern and erecting a 12-story dormitory tower above. It agreed to restore the original masonry facade and rebuild the interior. The facade was disassembled piece by piece and placed in storage until the construction was basically completed. A workman readies the second half of the original entablature to be placed back on top of the arch (right). And workers mount the original limestone finial on the peak of the arch (below). (Both images by Renee DeKona; courtesy of Suffolk University.)

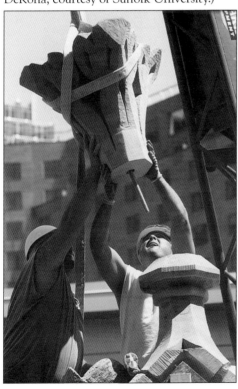

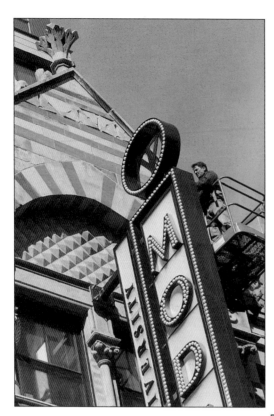

FINAL WORK ON NEW BLADE SIGN. Installed in the 1930s, the first blade sign, which dominated and obstructed the facade, was not considered historically significant by the Boston Landmarks Commission and was not part of the reconstruction. CBT Architects solved the problem with this modern LED backlit blade sign. (Image by Renee DeKona; courtesy of Suffolk University.)

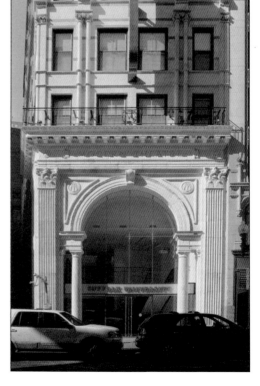

THE MODERN TODAY. The new theater, with 185 seats on the main level and a small mezzanine, now serves both the university and the general public with an extensive program of films, live performances, and conversation. Its annual cinema series provides screenings of classic and contemporary films and conversation with major filmmakers and writers. (Courtesy of Peter Vanderwarker.)

Four

The Orpheum Theatre

If theaters could talk, the Orpheum could tell stories going back more than 150 years, to its opening day in November 1852, its 32 years as the city's first music hall, its 15 years as a vaudeville house, its 56 years as a major movie palace, and its years since 1974 as one of the city's major venues for pop music concerts.

At the time of the Music Hall's opening in 1852, Boston had limited venues for music or opera. The Tremont Temple and the first National Theatre had both burned to the ground that year. Concerts by local or visiting musicians, artists, and groups were held mainly in smaller venues not designed for music, such as churches, auditoriums, playhouses, or even the New Boston Museum.

The Music Hall's huge auditorium served the city well for 50 years. The Boston Symphony Orchestra and the New England Conservatory of Music were founded here. The first Italian operas performed in Boston also played here.

But in 1900, when its largest tenant, the Boston Symphony Orchestra, moved to new quarters west of downtown, the Music Hall closed, its future uncertain.

By this time, vaudeville had become wildly popular in Boston. New York theatrical agent William Morris, envisioning a national chain like that of B.F. Keith, leased the Music Hall and convinced a local real estate developer to gut the interior and rebuild it from scratch.

Morris, however, was unsuccessful competing in Boston and elsewhere. In 1910, he sold all his theaters, including the Music Hall, to an up-and-coming theater chain owner named Marcus Loew. In time, Loew became increasingly dissatisfied with the design of the theater, particularly for film. This time the theater was totally gutted, redesigned, rebuilt, and reopened with feature films as the center of attention.

For several generations thereafter, this historic place was a central player in the saga of film going in Boston. And, it was its first movie palace.

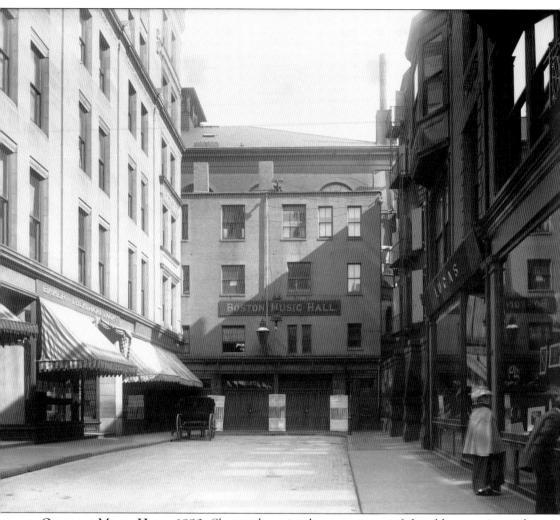

ORIGINAL MUSIC HALL, 1890. Shown above is what is now one of the oldest continuously operating theaters in the country. This photograph was taken from Hamilton Place, located off Tremont Street and between Bromfield and Winter Streets. Built in 1852, financed through a gift of $100,000 from the Harvard Musical Association, it was the first home of the New England Conservatory of Music in 1867 and the Boston Symphony Orchestra (BSO) in 1881. Its seating capacity of approximately 2,500 made it one of the larger theaters in the city. Besides concerts, the hall hosted many public events. On New Year's Day 1863, the Emancipation Proclamation was celebrated here by hundreds of abolitionists, including Frederick Douglass, Julia Ward Howe, Harriett Beecher Stowe, William Lloyd Garrison, and Harriet Tubman. (Courtesy of the Bostonian Society.)

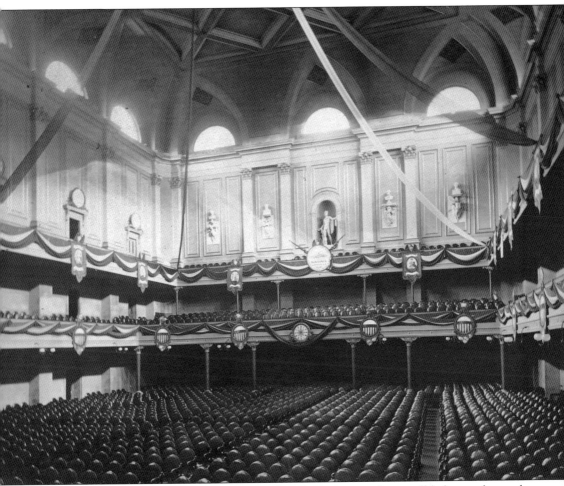

MUSIC HALL INTERIOR. Here is the original auditorium seating with a small balcony of several rows encircling the stage. The banners suggest a celebration, possibly Independence Day. Built with a movable proscenium, the configuration of the stage could be changed depending on the event. A second orchestra, the Boston Pops, was also founded here in 1885. Composed of many BSO musicians, its purpose, as envisioned by founder Henry Lee Higginson, was to present "a lighter kind of music." Originally called "Promenade Concerts," they proved highly popular, increasing attendance at the Music Hall. Though the nearby Tremont Temple produced the first operas in Boston and presented visiting authors, such as Charles Dickens, in its public hall, the Music Hall also offered operas and lectures. Gymnastics tournaments and wrestling matches also found a home here. (Courtesy of BPL Print Department.)

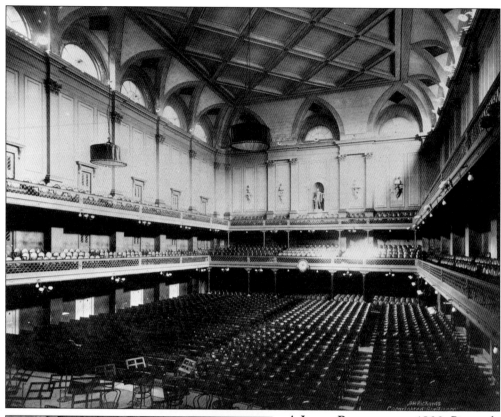

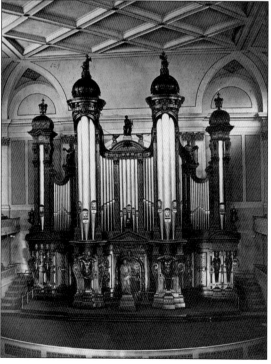

A LATER PHOTOGRAPH, 1900. Pictured are several changes, including the addition of electric lighting. Bigger changes were taking place outside. Construction of the new subway nearby was followed by talk of more road and office building. Fearing eminent domain and hall destruction, Boston Symphony Orchestra trustees decided to build their own home in the Back Bay and moved there in 1900. (Courtesy of BPL Print Department.)

ORIGINAL ORGAN. Commissioned in 1857, built by E.F. Walcker and Company of Ludwigsburg, Germany, and installed in 1862, the Boston Music Hall Organ was the first concert pipe organ in the United States. And with 5,474 pipes and 84 registers, it was, for some time, the largest. In 1884, to provide more space for the Boston Symphony Orchestra, it was removed to the Methuen Memorial Music Hall. (Courtesy of BPL Print Department.)

MARCUS LOEW COMES TO TOWN.
After success with penny arcades,
nickelodeons, and vaudeville houses
in New York, Loew cast an eye on
Boston. In 1910, he bought all of
William Morris's theaters, including
the old Music Hall, now called the
Orpheum. Loew saw the future as
film, not vaudeville. He also leased
the Columbia, St. James, and Globe.
Then in 1915, he set about updating the
Orpheum. (Courtesy of *Boston Herald*.)

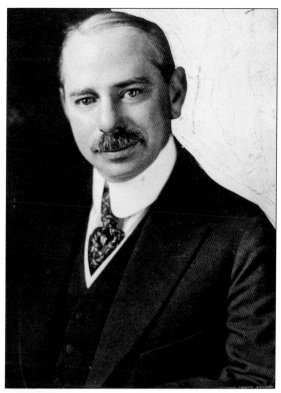

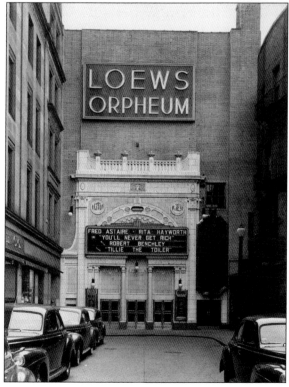

**ORPHEUM HAMILTON ENTRANCE,
1941.** Having hired Thomas Lamb
as his architect for the project,
Loew closed and gutted the original
theater, leaving only the north and
south walls. He then built a splendid
new $2-million home for film and
vaudeville, including this marquee.
The 2,927-seat design became Loew's
prototype for other theaters in his
growing empire. (Courtesy of THS.)

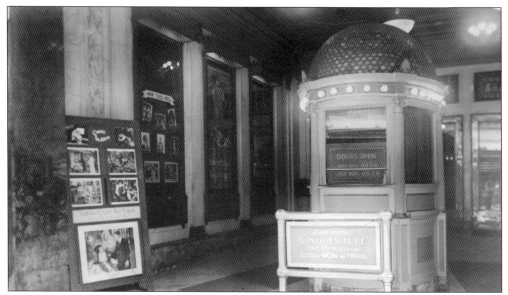

EARLY TICKET BOOTH, HAMILTON STREET ENTRANCE. After a year of construction, the Loew's Orpheum reopened on January 20, 1916. With continuous movies and vaudeville beginning at 9:15 a.m., there were four shows daily. Tickets sold for 10¢, 15¢, and 25¢. (Courtesy of THS.)

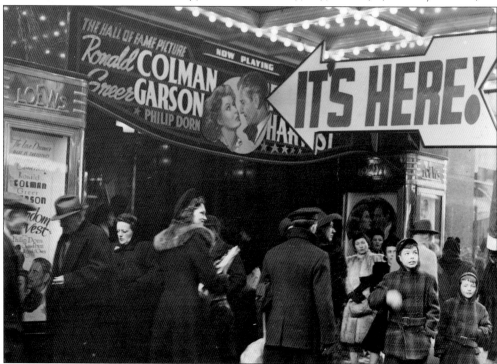

WASHINGTON STREET ENTRANCE, 1942. Set right in the middle of Boston's main shopping district, this was a busy entrance whether day or evening. All MGM films, like this Academy Award winner *Random Harvest*, had first runs at the Orpheum. At one point, there were three entrances—at Hamilton Place, on Winter Street, and here on Washington Street. This entrance no longer exists. (Courtesy of THS.)

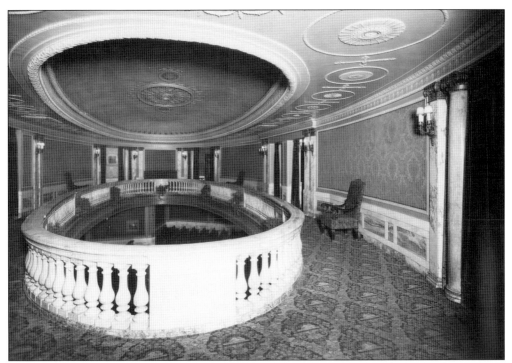

Washington Street Mezzanine. Washington Street customers then climbed a grand stairway to the mezzanine level. The design of the circular opening is reminiscent of many Federal buildings and very different from the Baroque style used in most early movie palaces. (Courtesy of THS.)

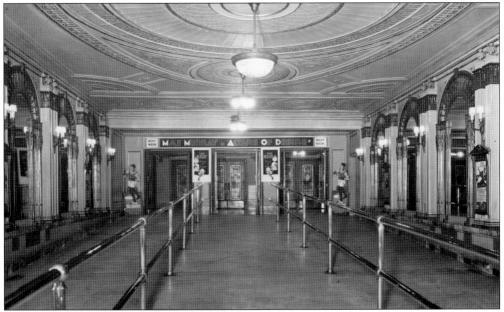

Upper Lobby. After purchasing tickets, Washington Street customers walked through this spacious lobby on their way to the orchestra or balcony. There was plenty of room for those waiting for the previous show to break. The circular fixtures and designs in the ceiling were typical of the Adam/Federal style used by Lamb throughout the house. (Courtesy of THS.)

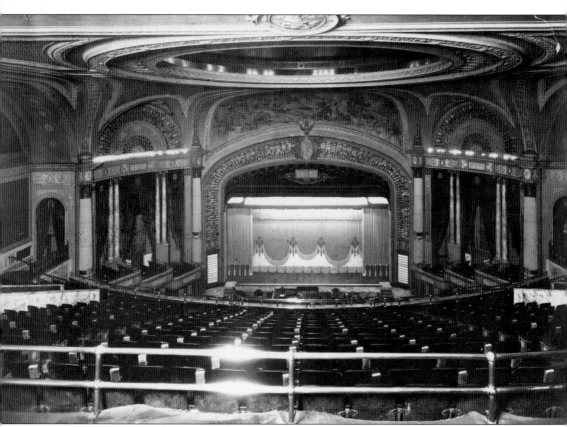

STAGE FROM MEZZANINE. Looking at this scene, one gets a sense of how enormous theaters were becoming. The new Orpheum seated 3,320, and it was a long way to the stage. Good acoustics were essential, as performers had to be heard without amplification. Accompaniment helped, and the Orpheum pioneered vaudeville accompanied by an orchestra rather than the traditional piano and drum. The Orpheum ran continuous performances—up to six shows a day at times. Union rules limited how many shows a day musicians could work. As a result, the theater had two house bands and two organists. Organs had the power and range to enhance silent film viewing. Years later, the Opera Company of Boston, under director Sarah Caldwell, put the acoustics to the test when they occupied the house from 1975 to 1979, and so did U2 and The Police, who both recorded live albums here in the 1980s. (Courtesy of THS.)

ORCHESTRA VIEW. The combination of Lamb's designs and ornamentations was a feast for the eyes. The sign at the bottom of the proscenium arch was often used to display the names of the performers. The proscenium arch was made of golden-hued glass and illuminated from behind. (Courtesy of THS.)

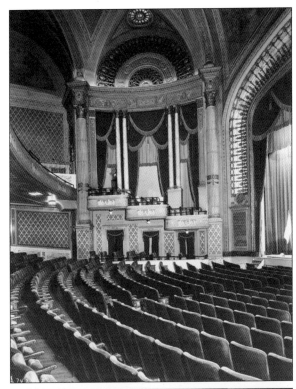

HOUSE VIEW FROM STAGE. The Orpheum's mezzanine and balcony were cantilevered over the orchestra and almost as large as its orchestra. This was a dramatic change from William Morris's reconstruction of 1900. Morris had added two balconies by means of older technology, with the balconies being supported by view-obstructing posts. (Courtesy of THS.)

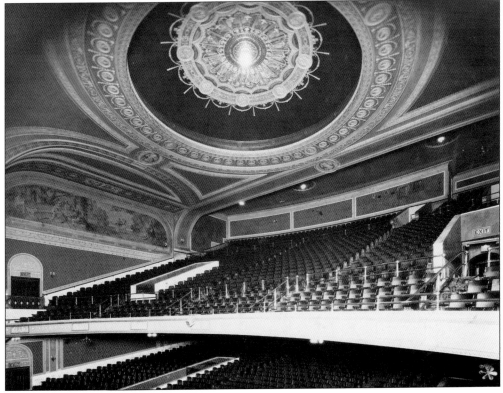

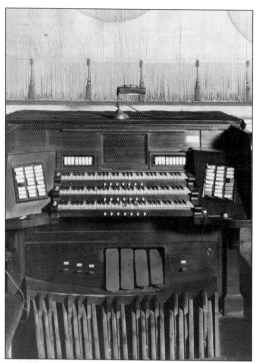

ORGANIST'S SPECIAL ROLE IN THE SILENT MOVIE DAYS. Writer J. Paul Chavanne recalls the following about sitting with his father in the first row, right behind the organist, and watching George "Windy" Warner: "I was utterly fascinated by his control over the manuals, stop tabs, and pedals. Though the instrument was more churchy than theatrical it provided a musical background that was far superior to the piano and drums. I was hooked on theatre organ." (Courtesy of THS.)

ORPHEUM'S CHOICE LOCATION, 1951. This photograph shows Washington Street, looking south. On the far side are, from left to right, the Orpheum, Gilchrist's, and E.B. Horn Jewelers. Filene's, with its sign and clock, can also be seen on the left. The top two windowed stories of the building behind the clock are part of Jordan Marsh. Not visible are other department stores, including R.H. White's and Raymond's. (Courtesy of THS.)

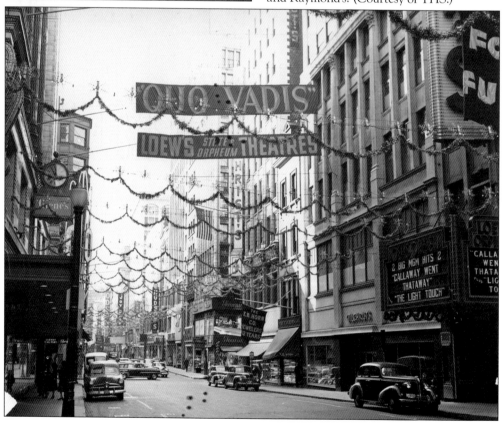

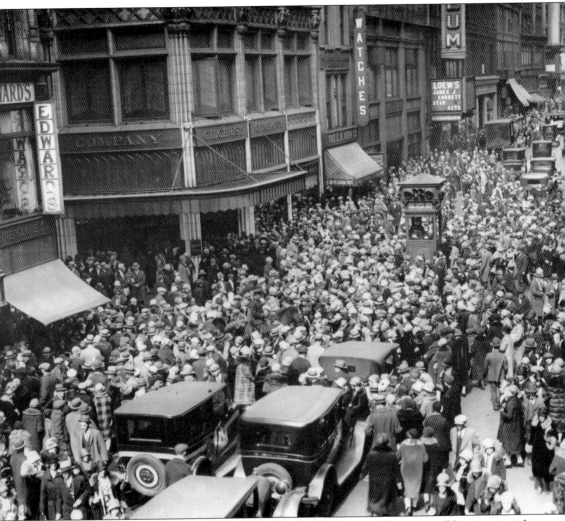

EASTER SHOPPING, 1921. If a theater owner wanted a location as close as possible to potential customers, it could not get much better than this one. This Leslie Jones photograph is looking north as workers and shoppers crowd Washington Street. Close to the city's financial district and Newspaper Row, everyone wound up at this intersection of Winter and Summer Streets regularly. These were the days before branch stores, and it was not unusual for people to be in and out of the same stores, several times a week. Note the traffic box in the center, the mounted policeman just below, and the subway entrance sign on the lower left corner. And just north, stands the Orpheum, highlighting a stage show plus former boxing champion turned actor James J. Corbett in a silent film, possibly *The Prince of Avenue A*. (Courtesy of BPL Print Department.)

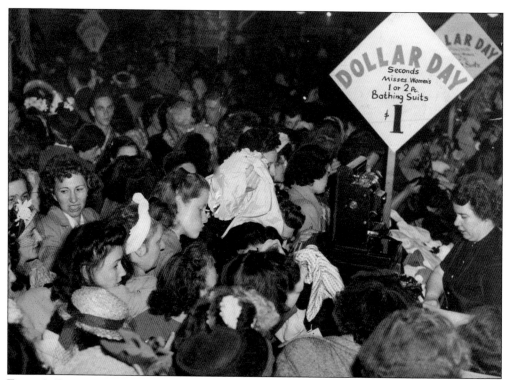

FILENE'S BASEMENT ON A TYPICAL DAY. Women shoppers jam the famous store, rummaging through piles of bathing suits to find their bargain. With its automatic markdown system and special promotions, many housewives would come to town two or three times a week, watching items until the price was low enough for their budgets. After a hectic visit, the reward was often a matinee show at the Orpheum. (Courtesy BPL Print Department.)

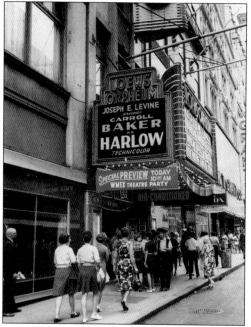

HARLOW'S SUMMER AUDIENCE, 1965. With an all-star cast, including Carroll Baker, Red Buttons, Leslie Nielson, Peter Lawford, and Angela Lansbury in addition to Bobby Vinton singing the theme, it was worth a visit to the Orpheum on this summer day. Films by Boston's Joseph E. Levine, which often had massive marketing campaigns, held special interest during the 1960s and 1970s, including *The Graduate* and *Hercules*. (Courtesy of THS.)

Five

THE LOEW'S STATE THEATRE AND BACK BAY THEATERS

GO WILD OVER SCREEN STARS
Crowd of 150,000 Greets Galaxy of Movie Actors—
Tremendous Reception Amazes Celebrities—
Nearly Mobbed by Throng.
Thousands Unable to Gain Admittance.

On the morning of March 14, 1922, *Boston Post* readers were greeted by the above four-column front-page banner headlines. The new Loew's State Theatre had opened. Directly below the headlines was a photograph of film legend Theda Bara getting "a rousing reception at the State House." A motorcade parade ran from South Station, along Washington Street, to city hall and the state house. It included 40 featured players of the day, including Nora Bayes and Mae Murray.

That evening, 4,000 filled the theater to capacity for the inaugural ceremonies and the new silent feature *The Champion*, accompanied by a 30-piece orchestra and starring Wallace Reid. Actress Mae Murray jumped into Mayor James Michael Curley's box and stood beside him while he made his speech.

In his address, theater magnate and owner Marcus Loew stated, "Boston will always have a soft spot in my heart. It was here where I first branched out after my success in New York. Loew's Orpheum was the forerunner of many theatres in the big cities of the United States. That is why I am building my second largest and most beautiful theatre right in the Hub."

Considering all this was happening before talking pictures, it seems remarkable today. Moviegoing, just as it was, had become Boston's most popular form of entertainment. It was also notable because the State Theatre was situated several miles south of downtown, which was where most of the other major movie and legit theaters, vaudeville and burlesque houses, top restaurants and bars, jazz clubs, and dance halls were ensconced. In a time of increasing affluence and mobility, why would it matter where this sumptuous movie house stood?

A short time after the State opened, Loew became a founding officer of MGM studios. That meant his theaters, like the State and Orpheum, had exclusive first run of all MGM films, from *Gone with the Wind* to *The Wizard of Oz.*

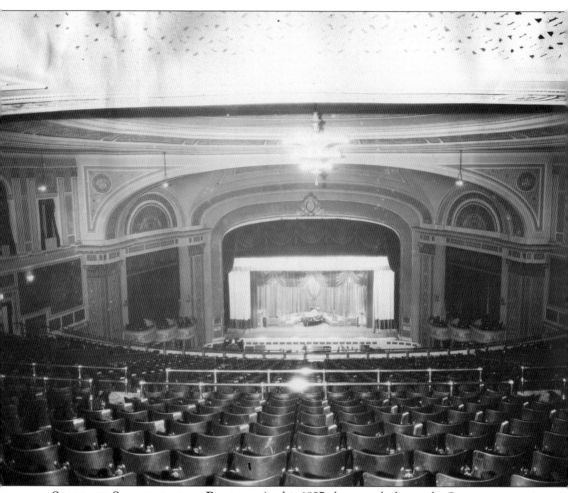

STAGE AND SCREEN FROM THE BALCONY. As this 1927 photograph shows, the State was a massive theater, almost as wide as it was long. With 3,583 seats, a large proscenium, a fully equipped stage, and a separate rehearsal hall, it seemed as suited to vaudeville as to film. The balcony alone held 1,25l, and there were 318 loge seats. As with the Orpheum, Lamb had used an understated Adam/Federal style with ovals and arches throughout. Its dominant colors were muted shades of brown, gray, and blue, while its ceiling had a gold double dome, and the curtains, which opened and closed at each showing, were red velvet. With the formation of MGM Studios just a few years after its opening, along with talking pictures in 1928, vaudeville was never a major feature. Audiences flocked to the State when it presented MGM's first major musical, *The Hollywood Review of 1929*, featuring Jack Benny as MC and performances by studio's contract players, including Norma Shearer, Joan Crawford, John Gilbert, and Laurel and Hardy. (Courtesy of THS.)

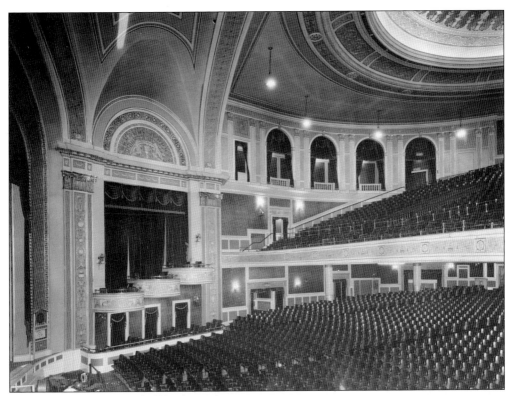

AUDITORIUM WALL. The hall had an open feeling even though the balcony was cantilevered over much of the orchestra. There were no posts, not even on the sides. The seating was about equal downstairs and up. There was carpeting throughout. And the ladies' lounge was replete with chairs, sofas, and huge mirrors. (Courtesy of THS.)

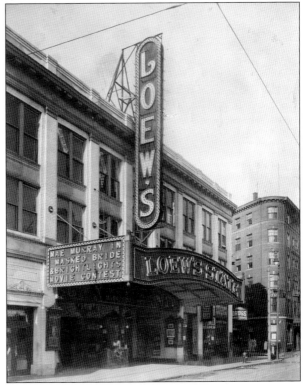

MARQUEE AND BLADE SIGN, 1925. Located on Massachusetts Avenue a block north of Symphony Hall and across from the Christian Science Mother Church, the theater was constructed into a large office building also housing a ballroom, a bowling center, and two smaller theaters. The film being shown is an early MGM drama with Francis X. Bushman and Basil Rathbone. Today, the site is part of the church's large housing development. (Courtesy of THS.)

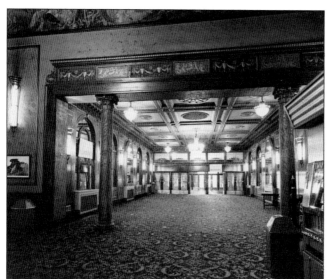

INNER LOBBY LOOKING TOWARD THE ENTRANCE. Moviegoers were welcomed into a spacious lobby, again with arches and high ceilings. In later days, the upper walls were filled with portraits of some of MGM's greatest stars, including Lionel Barrymore, Greta Garbo, Clark Gable, Mickey Rooney, Judy Garland, Gene Kelly, Esther Williams, Van Johnson, and Lassie. (Courtesy of THS.)

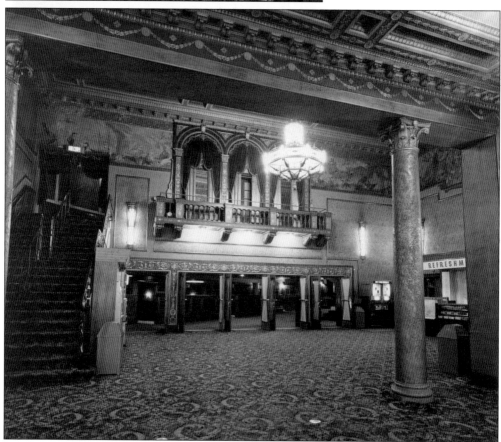

INNER LOBBY LOOKING TOWARD THE AUDITORIUM. Five entrance doorways lead to both the orchestra and, via the stairs (left), to the balcony. Note the refreshment area (right). By this time, Lamb had become Marcus Lowe's official architect and was building similar theaters throughout the country. (Courtesy of THS.)

ORIGINAL PIANO AND AVIARY. For youngsters here to see an *Our Gang* or *Lassie* film or a *Tom and Jerry* cartoon, another highlight was the Aviary, which housed a parrot named Oh Boy! and canaries named after opera stars. In the 1940s, the State and Orpheum usually ran identical films. But occasionally, if a new release was not doing well, it would be continued in one while the other played a rerun. (Courtesy of THS.)

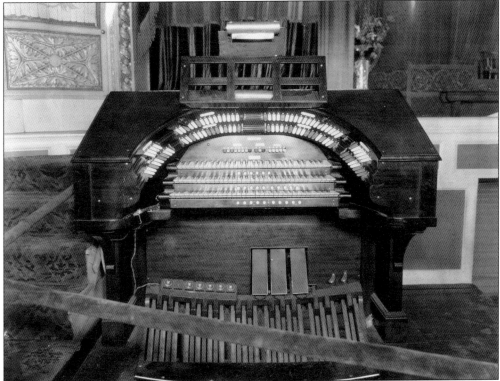

THE MIGHTY WURLITZER. The State boasted a three-manual 13-rank Wurlitzer 235 Special, Opus 1349. Good, creative organists were in high demand during the days of silent films when they often created their own special mood music to accompany dramas, comedies, and mysteries. They also played between films and led sing-alongs. While the State did not survive, its organ did. It now resides in Knight Auditorium at Babson College. (Courtesy of THS.)

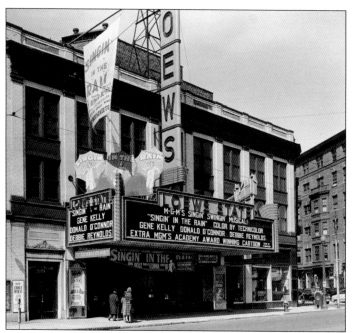

ANOTHER GREAT MGM MUSICAL, 1952. MGM was at its best with musicals, due largely to its skilled producer Arthur Freed; its inventive directors, like Vincente Minnelli and Busby Berkeley; its choreographers; and especially its stable of attractive singers and dancers, including Kathryn Grayson, Mario Lanza, Jeanette MacDonald, Tony Martin, June Allyson, Cyd Charisse, Debbie Reynolds, Donald O'Connor, Lena Horne, and Ann Miller. (Courtesy of THS.)

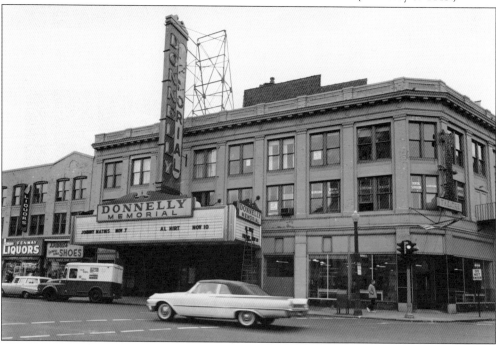

THE STATE CLOSES, AUGUST 1959. Unable to compete with suburban theaters, the State was sold to the Archdiocese of Boston with the help of a grant from the Donnelly Advertising Company. Used for various stage events, it was later sold to the Christian Science Mother Church. For the next nine years, the Donnelly Memorial/Back Bay Theatre showcased the Boston Opera Company, the Boston Ballet, and top entertainers, including, appropriately enough, a memorable appearance by one time MGM superstar Judy Garland. The theater closed for good in 1969. (Courtesy of THS.)

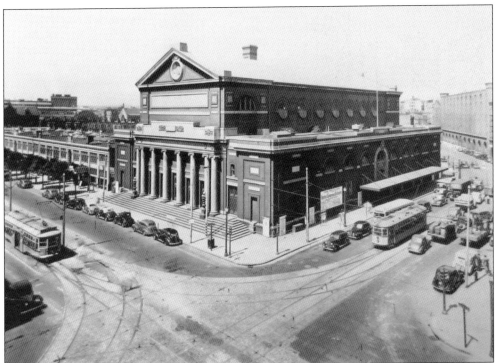

SOMETIME MOVIE PALACES. By the 1920s, almost all of Boston's finest playhouses and concert halls were equipped to show films. Some, like Symphony Hall (above), ran films that were compatible with their artistic missions. Others, looking to fill open dates on their calendars, were driven more by finances. The Loew's State stood one cross street away from the Symphony Hall. (Courtesy of Boston Symphony Orchestra.)

SYMPHONY HALL HOST TO WORLD PREMIERE, 1915. The Famous Players-Lasky Company chose Boston's magnificent hall for its world premiere of Cecil B. DeMille's *Carmen*, a silent film starring internationally known operatic star Geraldine Farrar. The film featured a plot loosely based on Prosper Merimee's novella and a score for an orchestra and vocalists loosely based on Bizet's opera. Farrar herself did not sing in the silent film or at the premiere. (Courtesy of Boston Symphony Orchestra.)

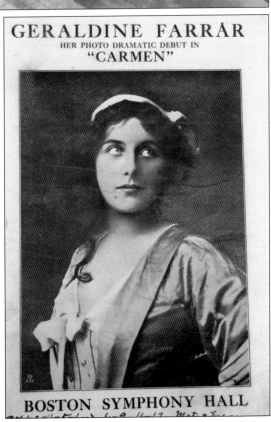

GERALDINE FARRAR
HER PHOTO DRAMATIC DEBUT IN
"CARMEN"

BOSTON SYMPHONY HALL

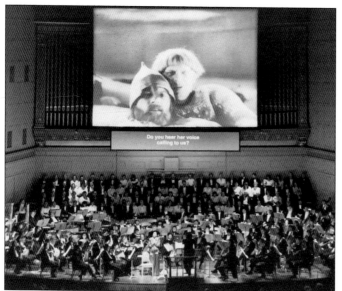

MEMORABLE FILM CONCERT, 1991. In this remarkable photograph, the Boston Symphony Orchestra is performing the Serge Prokofiev score for Sergei Eisenstein's classic 1938 motion picture *Alexander Nevsky*, while the film, without its soundtrack, runs on the screen with subtitles. From top to bottom, this photograph depicts the screen, the Tanglewood Festival Chorus, the orchestra, conductor Seiji Ozawa, and the audience. (Courtesy of Peter Vanderwarker.)

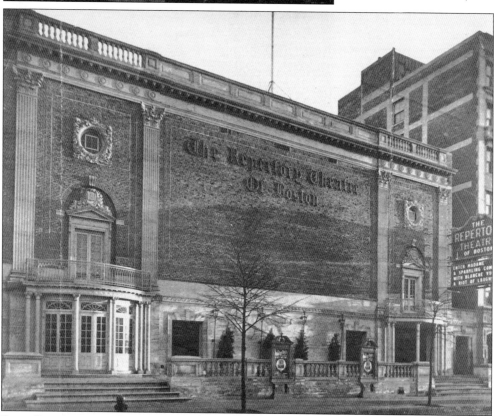

FROM PLAYHOUSE TO FILM HOUSE TO PLAYHOUSE. Built in 1925, two blocks from the Loew's State, the Repertory Theater of Boston lost its major tenant early on and became a film house. As the Esquire Theatre, it showed exceptional films until 1958, including the 1946 world premiere of Laurence Olivier's *Henry V.* Now owned by Boston University, it houses the Huntington Theatre Company.

THE UPTOWN THEATRE.
Within a short time, E.M. Loew added the 1,636-seat St. James to his growing Boston vaudeville and film house collection. Located on Huntington Avenue just east of Horticultural and Symphony Halls and within two blocks of the Loew's State, it was renamed the Uptown in 1929. Loew's used it exclusively for film. Through the years, it became particularly popular with Back Bay college students. With "popular prices," most lineups offered two major features, either recent hits or revivals. Programs were often genre or theme based, so a viewing of *Oklahoma!* might be paired with *Carousel* or two Westerns or two films by the same actor or actress. This publicity shot highlights the theater's distinctive vertical blade sign. The Uptown was demolished in 1968 to make way for the Christian Science Mother Church's huge expansion project, which also claimed the Loew's State. (Courtesy of *Boston Herald*.)

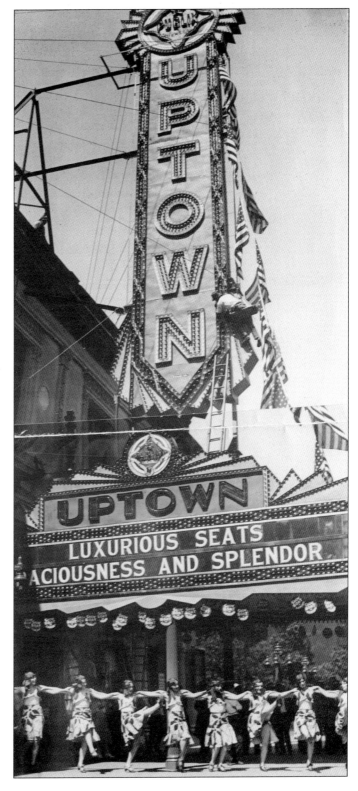

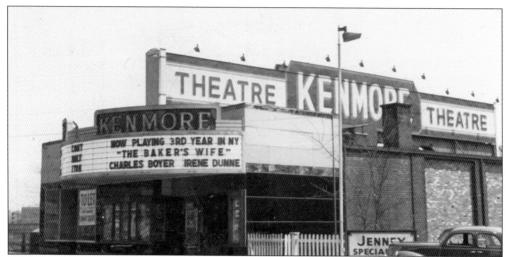

KENMORE SQUARE'S GEM. Located on Beacon Street just west of the square, this sleek 695-seat art house was built in 1939 and was managed by Lou Richmond. It was where people went to see films that mattered, like De Sica's *Shoeshine*, *The Red Shoes*, *Room at the Top*, or the hilarious *Carry on Nurse* series. It closed in the mid-1960s to make way for the Massachusetts Turnpike extension. (Courtesy of THS.)

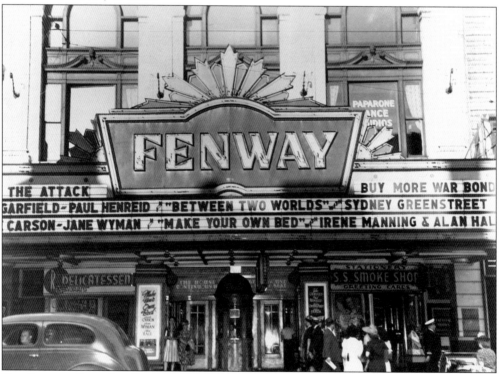

THE FENWAY. Opened in December 1915 at 136 Massachusetts Avenue and Boylston Street, the Fenway was architect Lamb's first theater project in Boston. Originally, patrons entered under a small marquee to a ticket lobby (the marquee above was added later). Independently operated at first, in time the Fenway was acquired by Paramount-Publix. After the Boston Paramount opened in 1932, the two theaters played first-run films in tandem. (Courtesy of Berklee College of Music.)

THE FENWAY INTERIOR. "The Fenway demonstrated that big, beautiful theaters could be constructed solely for the presentation of motion pictures," wrote historian Donald King. Originally seating 1,220, the Fenway was purchased by the Berklee College of Music. The theater was extensively renovated, the stage enlarged, and reopened as the Berklee Performance Center in 1976. (Courtesy of Berklee College of Music.)

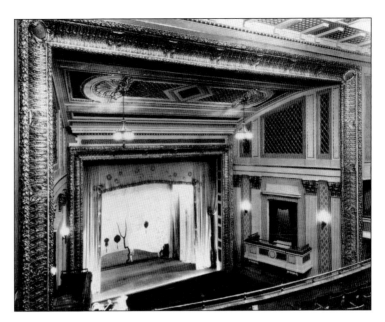

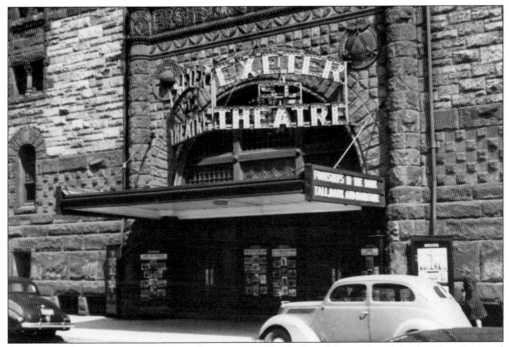

A BOSTON FAVORITE FOR 70 YEARS. Designed by Blackall and located within the First Spiritual Temple at Newbury and Exeter Streets, the Exeter Theatre was operated by member and trustee Viola Berlin, with proceeds supporting the temple. After buying a ticket at the box office from Viola or her sister Florence, the patron climbed the flight of wooden steps to the 1,200-plus seat orchestra and balcony. (Courtesy of THS.)

MOSTLY BRITISH. The Exeter was a favorite of college students, foreign film enthusiasts, and Anglophiles. This was the place to catch a Pathé News newsreel, a J. Arthur Rank film, a *Miss Marple* film, or the rising stars of British film from Guinness to Sellers. After Queen Elizabeth II's coronation in 1953, film was rushed to Heathrow, edited in flight, and delivered for immediate showing at the Exeter. (Courtesy of THS.)

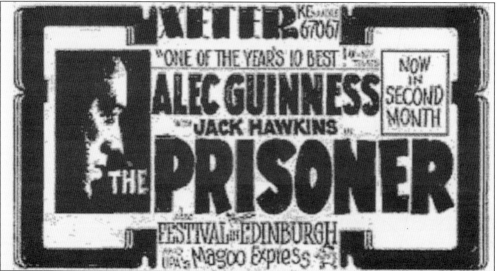

DISTINCTIVE IN STYLE. The Exeter was distinctive right down to its newspaper advertisements. Their heavy black borders, odd logo, and print font easily stood out from the dozens of other theater advertisements in the newspapers vying for attention each day. During the early 1970s, the Exeter had midnight showings of the *Rocky Horror Picture Show*. (Courtesy of First Spiritual Temple.)

Six

THE METROPOLITAN
THEATRE

Considered one the finest examples of the American movie palace, the Metropolitan Theatre first opened its doors on the evening of October 16, 1925. Boasting three elegant entrance lobbies and a jaw-dropping, chandeliered and mirrored Grand Lobby that was five stories high and nearly a block long, the theater also features grand staircases and luxury lounges, and, finally, a breathtaking sweeping auditorium consisting of orchestra, mezzanine, and balcony.

Built at the height of the Roaring Twenties, it was designed for both stage and film. Rivaling the Radio City Music Hall in size and grandeur, it was soon being called "The Crown Jewel of Boston," "The Showplace of New England," and "Boston's Movie Cathedral." With its opening, the Publix Theatre Corporation finally had the large Boston flagship theater it had been seeking for years to exhibit their Paramount films.

On the evening of October 16, 1925, twenty thousand people gathered outside the theater before the performance. Among the celebrities were reigning stars of the day Thomas Meighan and Lois Wilson, Governor Fuller, Mayor Curley, and top Paramount officials Jesse L. Lasky and Adolph Zukor. The following afternoon and evening, 30,000 entered the theater, filling the seats and lobbies and setting an all-time record.

From its earliest days right through today, it has brought to Boston an unrivaled array of world-class theater, music, dance, and film. The list includes the Metropolitan Opera; the Bolshoi Ballet; musicals, including *Phantom of the Opera*, *Riverdance*, *Ragtime*, and *Sunset Boulevard*; big bands, like those of Duke Ellington, Tommy Dorsey, Benny Goodman, and Gene Krupa; and entertainers, from Frank Sinatra to Jerry Seinfeld. In addition, Al Jolson, Bob Hope, and Dorothy Lamour performed at war bond drives. The tradition continues.

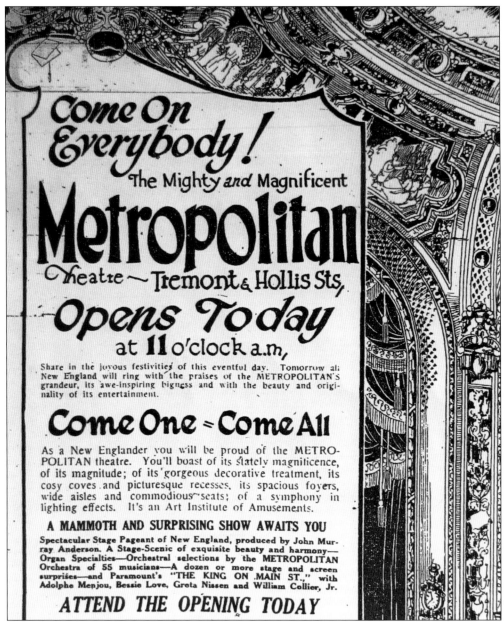

GRAND OPENING, OCTOBER 16, 1925. From the very beginning, the Metropolitan was big, bold, and confident, as is apparent from this opening day advertisement that ran in Boston's morning newspapers. The invitation may have been a bit "over the top," but the theater fulfilled the advertisement's promises to the thousands who attended. The Met, as it quickly became known, was indeed unlike any other theater, concert hall, or museum in the city or in all of New England. This was one of architect Clarence Blackwell's crowning achievements. With the exception of New York City's Radio City Music Hall, few stage and screen houses in the country could compare in size and seating capacity. Though the advertisement touts 5,000 seats, the actual number was 4,400. Providence's Metropolitan held just over 3,000. As for luxury, only Fox Theaters in Detroit, Atlanta, and St. Louis came close. (Courtesy of BPL Print Department.)

CHANGE IN NAME BEFORE OPENING. In this vintage postcard is the Met entrance at 268 Tremont Street. The Wilbur Theater and Stuart Street are farther left. Directly across the street from the entrance stands the Shubert Theatre. Housed entirely within the large office building, one gets little sense of the enormity of the theater, which encompasses all of the building's lower floors and extends to the rear as well. While under construction, what was to become Boston movie mogul Nathan Gordon's Capitol Theatre and Hotel fell short of funding. A public stock offering led to new ownership and a new name. The hotel concept was abandoned. Total cost was reputed to be $8.5 million. The street stretching back from Tremont Street was Hollis Street with its popular Hollis playhouse. Today, it is just a small alleyway, next to a large parking garage and the New England Medical Center complex. (Courtesy of BPL Print Department.)

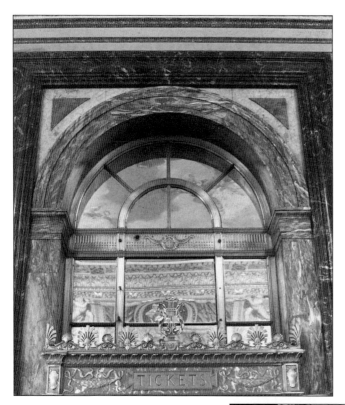

ENTRY LOBBY. The doors under the canopy lead to a spacious lobby and a large box office area (left). With three ticket windows, the area is framed by bronze and marble and topped off by this striking arch. At the time of the opening, tickets cost 35¢ on weekdays and evenings and 75¢ on weekends.

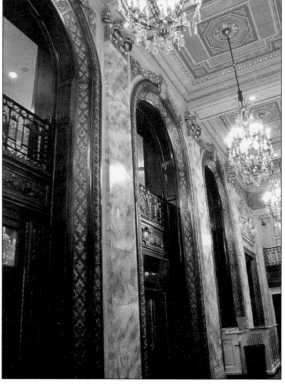

MARBLE DOORWAYS. Entering the second lobby, people are immediately introduced to the French Renaissance style that defines the entire theater—the marble doorways, the glittering crystal chandeliers, and the elaborate railing work and decorations. Though a low ceiling gives little indication of what lies ahead, people are seeing, to use movie terminology of the day, "a preview of coming attractions."

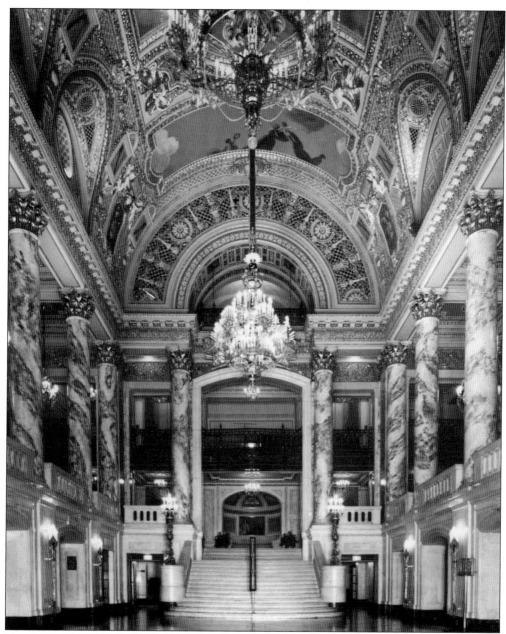

THE GRAND LOBBY. Modeled after the plan of architect Charles Garnier's Paris Opéra Comique and decorated in the Louis XIV style, this space alone is worth the price of admission. Once inside, patrons understand why the theater has been called a movie cathedral. Five stories and 90 feet high, the room is almost a block long and wide enough to hold several thousand people, as architect Blackall intended. While 4,000 people were in the auditorium watching a show, thousands of others waiting for the next performance would be here—admiring the gold-plated chandeliers or just people gazing. At the far end of the lobby stands "the nook," still a favorite spot for taking family pictures. The lobby has been the setting for many films, including the *Witches of Eastwood* and a *Pink Panther* supposedly set in Paris. Patrons from throughout New England still marvel at its breathtaking elegance.

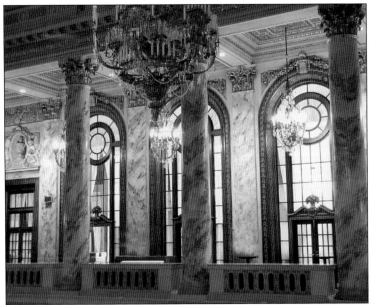

SECOND-FLOOR PROMENADE. There was plenty of room for strolling, with the wide walkways that ran on three sides. At the opening festivities, Paramount's founder Adolph Zukor promised the city "a theater of mountainous splendor, a place of fabulous grandeur and stupendous stage presentations." The next morning the *Globe* called it an "architectural marvel."

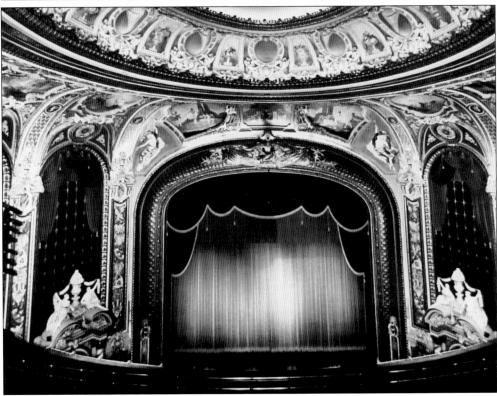

ORIGINAL STAGE. The opening program featured Adolphe Menjou in the silent romantic comedy *The King on Main Street*. The new E.M. Skinner 4/51 organ was also heard. The stage show was an original production featuring the corps de ballet and a 44-piece orchestra. In the 1930s, radio's top stars would appear here, including Kate Smith, Rudy Valee, and Amos n' Andy. (Courtesy of Citi Performing Arts Center.)

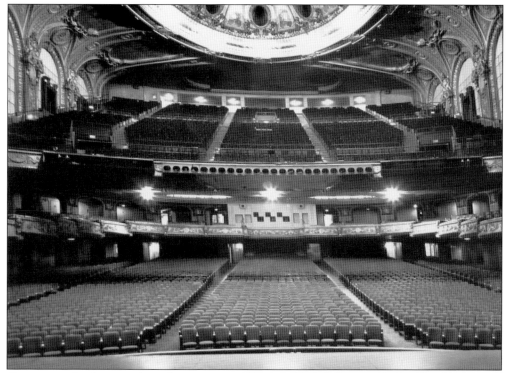

ORCHESTRA. Looking out from the stage, a performer could easily be overwhelmed by the enormity of the house, hopefully filled with ticket holders waiting to be entertained. The theater remains one of the largest in the country. (Courtesy of Citi Performing Arts Center.)

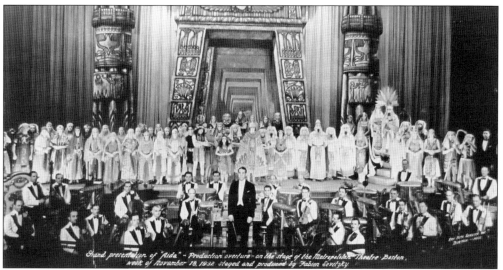

AIDA AT THE METROPOLITAN, 1932. Much more than film was offered on the Met's stage, as seen in this image, as the theater's Grand Orchestra and 100-voice chorus receives applause after performing the opera's overture. Met conductor Fabien Sevitzky staged and produced the concert. (Courtesy of Citi Performing Arts Center.)

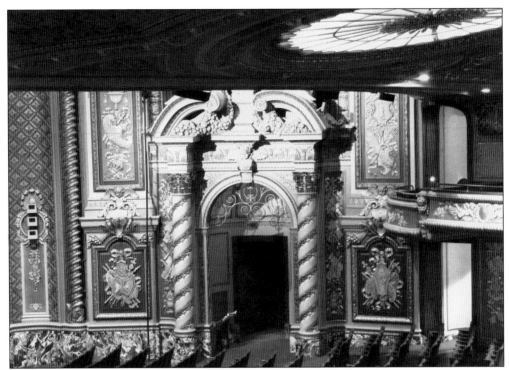

ORCHESTRA-SIDE ENTRANCE. The Blackall design called for elaborate auditorium entrances with marble bases, decorative columns, and heavily detailed arches. Note the ornamentation on each side, the loge boxes at the mezzanine level, and the ceiling and lighting fixtures high above the orchestra seats.

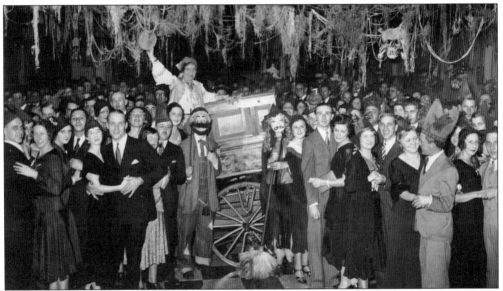

DANCING AT THE GRANDE LOUNGE, 1932. Each night, up to 500 patrons could dance to the music of Sid Reinherz and his Met Collegians before or after the stage show and film. The Met was the first theater in America to offer this service. In this Halloween night photograph, the Met's hurdy-gurdy, imported from Italy, is providing some of the music. (Courtesy of *Boston Herald*.)

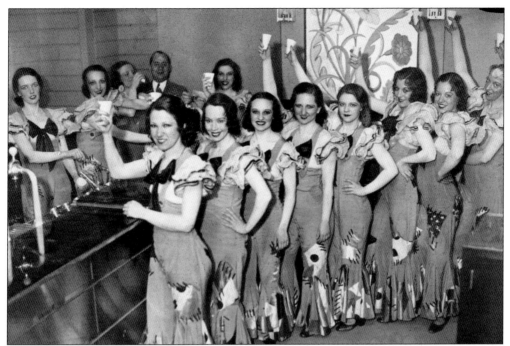

SODA TIME, 1932. The Met's soda fountain was another popular feature with theatergoers. In this publicity shot, dancers from the Met's company line up between performances. The Met produced its own stage shows under the direction of John Murray Anderson (possibly the man in the background). Anderson went on to produce reviews at Radio City Music Hall and on Broadway. (Courtesy of *Boston Herald*.)

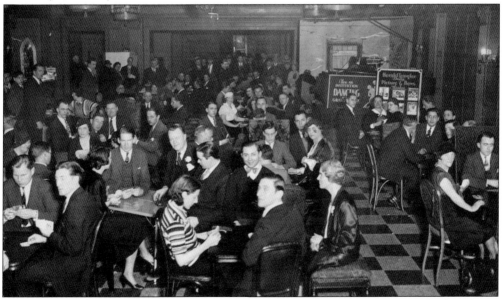

BRIDGE ENTHUSIASTS IN THE GRAND LOUNGE. An afternoon crowd of contract bridge players pauses for a picture before getting back to the games. Part of theater policy was to draw people to the Met day and night for shows, films, and socializing. Included in the crowd is Barbara Hagen-Burger (foreground), the Met's bridge hostess. (Courtesy of *Boston Herald*.)

SEATING PANEL. Located in the Grand Lobby, this panel lit up to identify open seats during performances so uniformed ushers could bring new arrivals directly to those seats. The Met corps of ushers also carried flashlights and had elaborate flashing codes for alerting each other to open seats. The goal was to have every seat occupied without interrupting the rest of the audience.

AUDITORIUM CEILING AND WALL ORNAMENTATION. No space in the theater was left undecorated. But this was the 1920s, and in a case like this, money was no object. One could spend a whole day exploring all the gilded or sculpted figures, but thousands would come and go each day without noticing such detail.

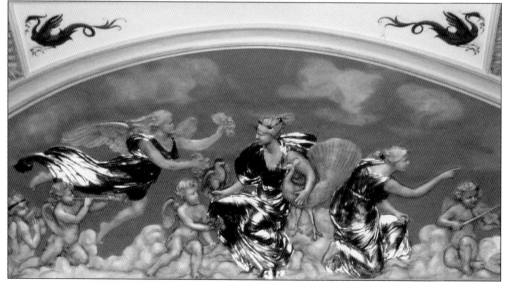

CENTRAL CEILING MURAL. Magnificent murals appear throughout the Metropolitan. Here, the central mural painting is the work of Edmund Philo Kellog, a well-known artist of the day. A purported $10,000 worth of gems was used to decorate the mural. If separate architectural and design tours of the building were not held, they should have been.

MORE ORCHESTRA DETAIL. The theater opened during the silent movie days. Paramount Studios had a growing number of talents under long-term contracts, including Mary Pickford, Gloria Swanson, Rudolph Valentino, William Powell, W.C. Fields, Clara Bow, Warner Baxter, and director Cecil B. DeMille.

MORE IMAGES OF FIGURINES AND ORNAMENTATION. The Metropolitan was reportedly built at a cost of $8.5 million in 1925 currency. For film, its size was not a problem as it had a giant screen. But when individual performers appeared on stage, much of the audience rightfully felt removed, especially those seated far to the sides or in the back. And when the house was only partially filled, one might be sitting closer, but there was still a lack of intimacy. The theater remains one of the largest in the country and certainly the largest in New England.

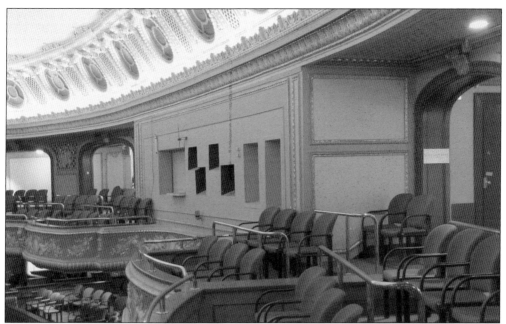

PROJECTION BOOTH. The heart of any movie theater was the projection booth. Good film projectionists were in high demand, especially in the late days of silents and the early days of talkies, when technology changed rapidly. Some theaters had only stuffy closet-sized rooms holding both equipment and projectionist. At the Met, projectionists had a large booth (center) where they could change reels, repair films, and maintain the equipment.

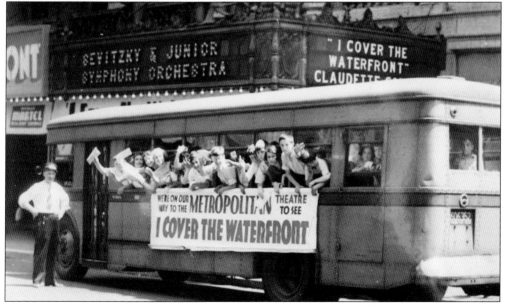

BIG CITY EXCITEMENT, 1933. Here, 35 children, the winners of a contest held at Roxbury and Dorchester theaters, are seen at the Met, "where they enjoyed a film premiere, a stage show, and were served ice cream, cake, and candies" by the theater manager. Photograph stories like this were common, as theaters worked hard to get free space in Boston's seven daily newspapers. (Courtesy of *Boston Herald*.)

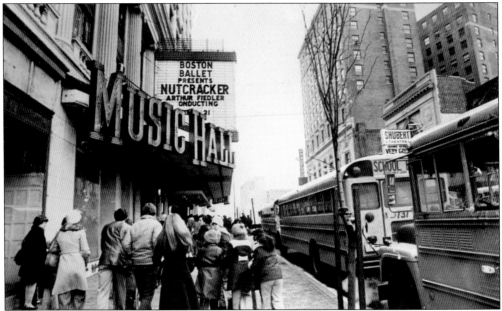

REINCARNATION. Like most downtown theaters, the Met fell on hard times by the late 1950s. Sold to the New England Medical Center in 1962, it was immediately leased by Ben Sack, the entrepreneurial owner of two recently revived houses nearby. He renamed the theater the Music Hall and brought back live performances to go along with top films. It soon became home to the newly formed Boston Ballet Company. (Courtesy of *Boston Herald*.)

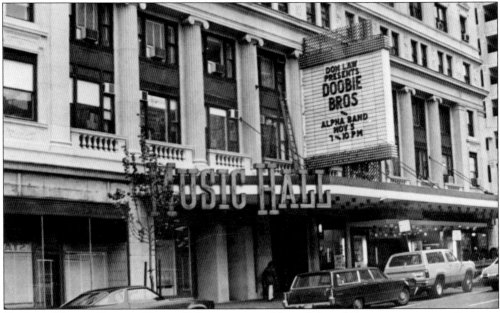

BRINGING PEOPLE BACK TO TOWN. Tickets went quickly and the sold-out signs went up whenever pop music groups, like the Doobie Brothers, came to town. Sack's management team also made room for the New York Metropolitan Opera Company, ballet companies, and solo performers from around the world. At the same time, Sack still continued to run top new films throughout the year. The Sack era lasted until 1980. (Courtesy of *Boston Herald*.)

ANOTHER ERA. In 1980, the nonprofit Metropolitan Center, Inc., took over operations from the Sack organization. In 1983, after a roof beam collapsed, the theater was shuttered. A gift of $1 million and a challenge grant of $3 million by Dr. An Wang, the founder of Wang Labs, eventually allowed for restoration. The theater was subsequently named the Wang Center for Performing Arts. Pictured here is Josiah "Joe" Spaulding, who was named president in 1987. (Courtesy of Citi Performing Arts Center.)

OVERDUE RESTORATION. Under Wang and Spaulding's leadership, $9.8 million was raised, and a long overdue restoration began in 1990. Besides a new roof, the stage house was restored and expanded to allow for Broadway road shows. The project took three years, with the theater closed intermittently. For a number of years following, movies returned to large appreciative audiences in an annual series of classic film presentations. (Courtesy of *Boston Herald*.)

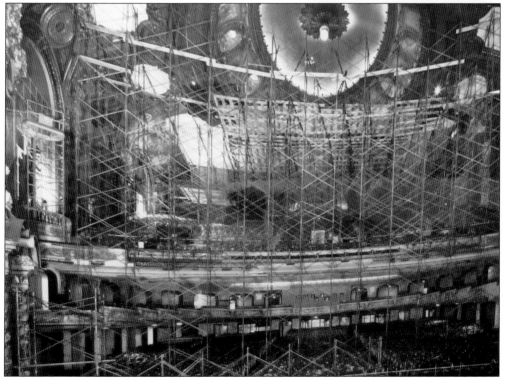

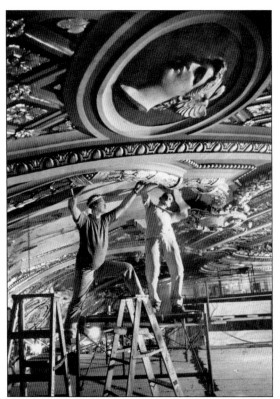

NO DETAIL OVERLOOKED. Every room, every work of art was repaired and restored. As a guide for the restoration work, Conrad Schmitt Studios conducted an investigation of the original colors and finishes. Two teams of artists and decorators worked around the clock to restore the elegant decorations, gilded moldings, murals, and scagliola and marbleized surfaces and completed the restoration in just 18 weeks. (Courtesy of *Boston Herald*.)

BETTER THAN EVER. Reopened in 1994, the Wang Center took over operation and management of the Shubert Theatre, its longtime neighbor, designating it as a home for a number of local not-for-profit performing arts organizations. In 2006, a long-term partnership was formed with Citigroup, with the Wang and Shubert now operating as part of the Citi Performing Arts Center.

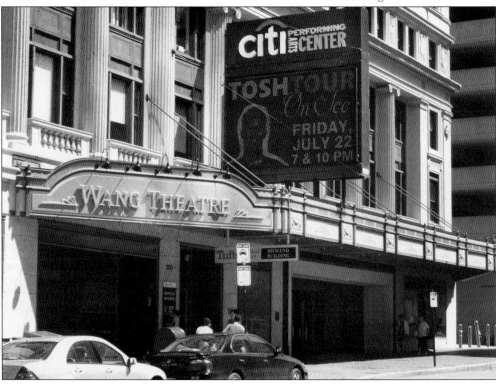

Seven

THE KEITH
MEMORIAL THEATRE

When "The Father of Vaudeville," Benjamin Franklin Keith, died unexpectedly in 1914, his entire enterprise fell into the hands of his son Andrew, which included theaters across the country. Four years later, Andrew died, a victim of the 1918 influenza epidemic. Most of his assets then passed to Edward F. Albee, B.F. Keith's longtime friend and partner. There were still other vaudeville circuits at the time, but Keith's had the biggest stars, the biggest shows, and the biggest audiences. It was quite a gift. In the years that followed, Albee concentrated on expanding his circuit until the mid-1920s, when it reached between 350 to 400 theaters.

At some point, Albee began thinking about a proper memorial to Keith in Boston. He envisioned a theater of grand proportions, but none of his current venues would do. This had to be grander. He decided that a new theater would be built. He hired the well-known architect Thomas Lamb, who had designed the reconstructed Orpheum in 1914 and the Fenway the following year. After three long years of construction, this remarkable theater, built with the finest materials from all over the world, was opened on October 29, 1928.

As a film house, the Keith Memorial would have its good years and bad. But its years as a vaudeville house were ending. By the time of the opening, Albee had already sold controlling interest in his vaudeville circuit, including all his leased or owned theaters, to another well-known Boston figure, Joseph P. Kennedy. Chair of a new entity that included a film studio, Kennedy subsequently named it the Radio Keith Orpheum Corporation (RKO). Albee died a year after the opening of the Keith Memorial, and Kennedy took complete control of his theaters. Unlike Albee, Kennedy saw film, not vaudeville or stage, as the future of the business and began converting many of the chain's theaters to film only. RKO Radio Pictures increased production, and by 1933, the Keith Memorial, the entertainment palace dedicated to the founder of vaudeville, became a full-time movie palace.

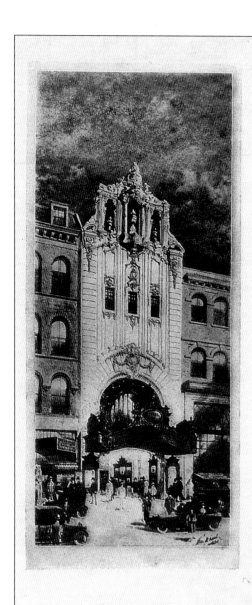

The New
B. F. KEITH
MEMORIAL
THEATRE

GRAND OPENING, KEITH MEMORIAL THEATRE, 1928. The cover on the program for the theater's opening depicts the 96-foot-high facade of the new theater at 539 Washington Street. The opening was attended by some of vaudeville's greatest stars, including George M. Cohan, Lew Fields, and Al Jolson. Governor Fuller and Mayor Malcolm E. Nichols were there along with former mayor James Michael Curley. The host for the occasion, E.F. Albee, and board chairman Joseph P. Kennedy represented RKO. Stage entertainment, including juggler Jack Pearl, the Foy Family, song stories, a comedy skit, and an ensemble dance featuring 12 "girls," followed the speeches. Then came the feature film *Oh Kay!* starring Coleen Moore. The film was a silent version of the Gershwin Broadway musical with organ accompaniment. The program lasted until after midnight. (Courtesy of Boston Opera House.)

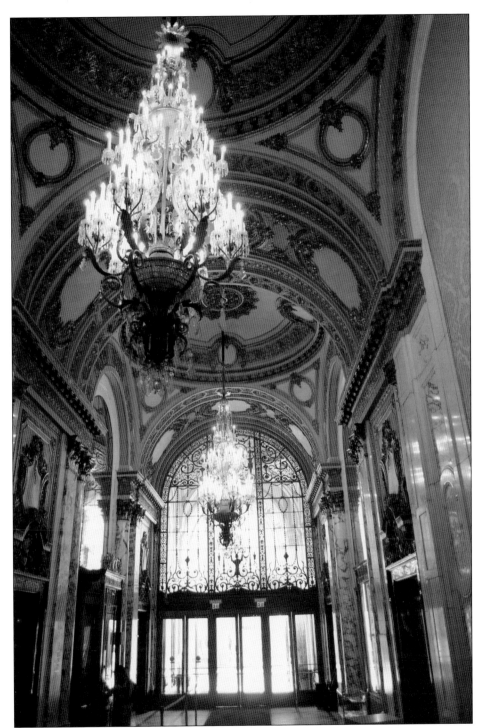

ENTRANCE LOBBY. Just a few steps from Washington Street, the lobby was and is, as one magazine put it, "a true extravaganza of marble, mirrors, and crystal." Being two stories high, it begins with a glass wall, which allows daytime light; six bronze framed entrance doors; two magnificent chandeliers; and a number of bronze display frames. The box office can also be seen at left.

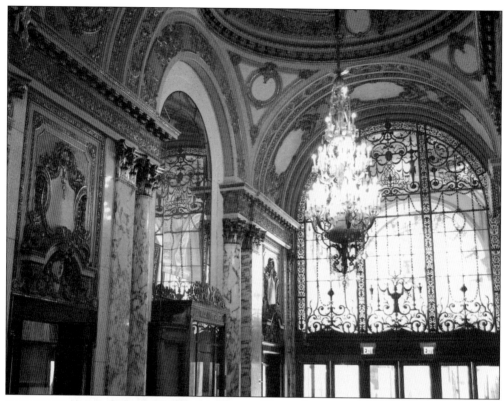

CLOSER LOOK AT THE CHANDELIERS AND CEILING DETAILS. Albee was a specialist in theater construction. He decorated his lobbies with lots of marble that was quarried in Italy. No plaster here. His love of red and gold decor came from his circus days. Pure gold and other shiny glittering materials can be found throughout the theater.

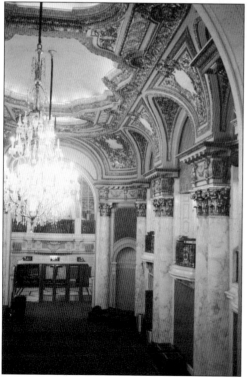

LOBBY CONTINUES. Facing away from the entrance, the lobby became a promenade lined with shops that led to the original Crystal Tunnel built by Keith for his old theater and ended at Tremont Street. The tunnel no longer exists, and today, the promenade is relatively short.

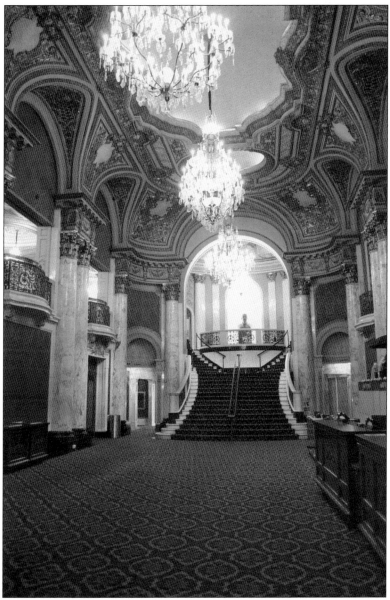

THE GRAND LOBBY. After passing the ticket booth, one turns right and enters the Grand Lobby. Here, Lamb's full Baroque design unfolds immediately. This is the main gathering place for the up to 2,900 theatergoers as they enter or leave the theater. A long and wide, black-and-gold carpeted floor creates a warm, quiet atmosphere. An entrance to the orchestra can also be seen on the far left. Straight ahead is the 23-step white marble grand stairway leading to the balcony foyer. Near the top, enclosed by the railing, is a circular space holding a memorial to Keith. A complete restoration by FA+A Architects took place before the theater's reopening in 2004, beginning with the exterior front facade and trim. Internally, the murals, wall fabrics, lighting, marble, and painted finishes were restored to their original condition. Also, sculpture work, gold leaf finishes, marble columns, grand staircases, chandeliers, and walnut and oak paneling were restored. There was an expansion of the stage house to accommodate Broadway shows. New electrical, mechanical, and fire protection systems were installed.

BUST OF B.F. KEITH. Many would say this bust atop a black marble base, not the auditorium, is the heart of the building. After several years in New York with Bunnell's and Barnum, Keith landed in Boston penniless. Financed by a friend, he opened a dime museum followed by an ever successful career bringing entertainment to the public. (Courtesy of *Boston Herald*.)

MEZZANINE CEILING. On the ceiling of this small circular space directly above the Keith bust is a magnificent mural similar to the one appearing on the auditorium's ceiling. Art for the Keith Memorial was acquired from around the world. No expense was spared. The Historic American Buildings Survey (HABS) called the Keith Memorial one of the finest examples of the moving picture palace at its highest stage of development.

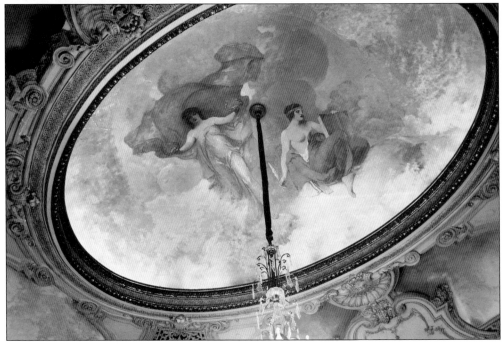

GATHERING SPACE ON BALCONY FOYER. Again, this photograph was taken in the midst of arches, mirrors, crystal chandeliers, and carpeted floors. Note the chairs, sofas, tables, and wall paintings. The far stairway leads to the back of the balcony. Lamb's color scheme was ivory and gold, the same colors used in most Keith-Albee circuit theaters. (Courtesy of THS.)

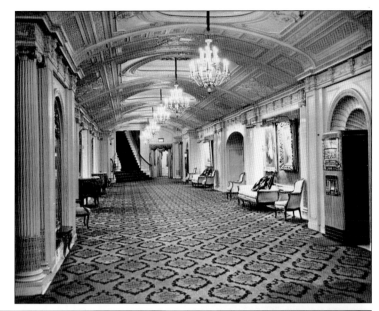

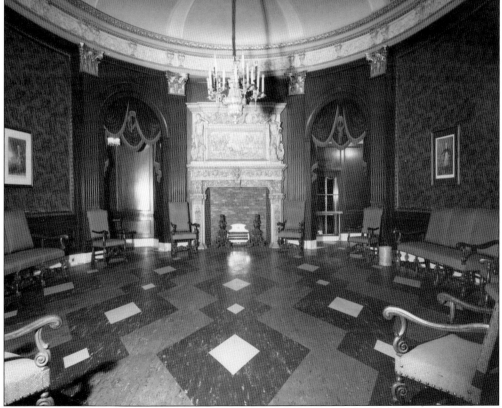

MEN'S SMOKING LOUNGE. In this early view, one can see the tiled floor and the centerpiece, a nonfunctioning fireplace with a massive ornamental chimneypiece above it. The ladies' parlor was also located on this floor. Two stories down, running off the Grand Lounge, were large women's and men's suites. (Courtesy of THS.)

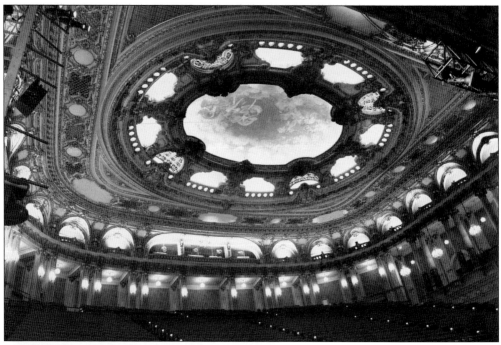

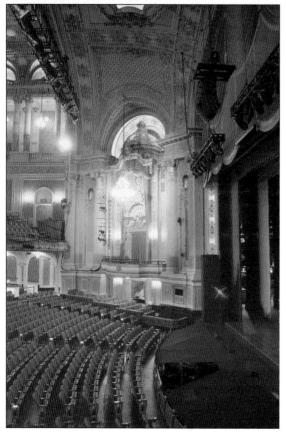

BALCONY AND DOME. Sitting in this area, even when it is darkened at show time, it is impossible not to feel as though it is one of the grandest spaces of any theater. The green plush seating is one thing, but the walls and ceiling dome with its *Heavenly Paradise* mural is another. The Baroque design is similar to that of many European opera houses.

ORCHESTRA TODAY. Even with the addition of lighting and sound equipment, the former Keith Memorial, now the Opera House, continues to shine. In earlier days, the back stage contained comforts for the vaudeville artists, such as a gym, billiard room, beauty parlor, barbershop, and nursery with a trained nurse. One gets the sense that, even with today's expansive stage house, B.F. Keith would feel very comfortable here.

KEITH MEMORIAL TREMONT STREET ENTRANCE, 1938. Taken from Boston Common, this photograph shows the original facade of the B.F. Keith New Theatre. Though the current RKO film is not much remembered, it was entertaining to filmgoers at the time. The comedy *Having Wonderful Time* starred Douglas Fairbanks Jr. and RKO's biggest star, Ginger Rogers, along with young future stars Lucille Ball, Eve Arden, Red Skelton, and Jack Carson. (Courtesy of BPL Print Department.)

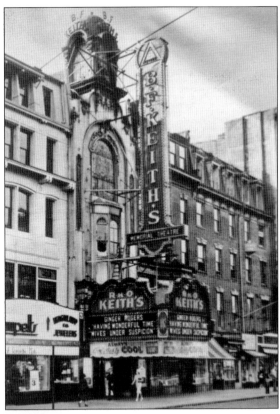

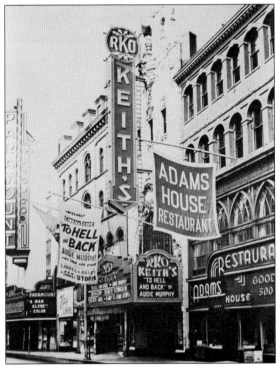

KEITH MEMORIAL WASHINGTON STREET ENTRANCE, 1955. Competing signs, banners, and marquees all but cover the original facade, giving no sense at all of the movie palace within. Universal's *To Hell and Back*, starring war hero Audie Murphy, was a huge success. The cofeature, *Utopia*, was made in France and was also Laurel and Hardy's last film together. (Courtesy of BPL Print Department.)

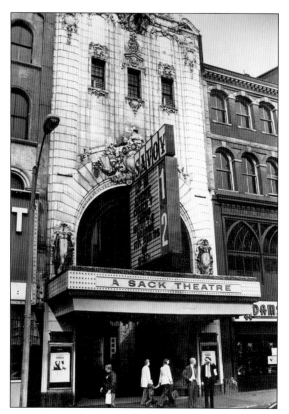

SACK THEATRES ERA, 1965 TO 1975. By 1965, the Keith was on the verge of closing when up stepped Ben Sack. He bought the storied house, quickly renovated it, and reopened it under a new name. He eventually bricked up the proscenium arch and installed a second screen on the stage. After 10 years, he sold it to Sarah Caldwell's Opera Company, resulting in another name change. (Courtesy of *Boston Herald*.)

OPERA HOUSE BRINGS NEW LIFE TO WASHINGTON STREET. Caldwell's Opera House was forced to close in 1990. After sitting empty for a decade, it was acquired by the Clear Channel entertainment conglomerate and underwent a $30-million restoration and expansion, reopening in February 2004. Today, the Opera House regularly presents the Boston Ballet, touring Broadway shows, and big-name artists. The "Palace of the People" lives on. (Courtesy of Peter Vanderwarker.)

Eight

THE PARAMOUNT THEATRE

The story of Boston's Paramount Theatre would make a good movie. It would be about beauty, innovation, success, failure, abandonment, rescue, transformation, and rebirth. The cast of characters would include Hollywood moguls, imaginative architects, dedicated city officials, a forward thinking college, and a cast of thousands of moviegoers. It would begin during the Depression and would bring back good memories of favorite films and film stars and bad memories of its closure and years of decay. For now, it would have a happy ending—at least for the next several generations. There would be much to tell and much to see.

In fact, many have already seen "the movie." They lived it. They frequented the Paramount. They remember films and movie stars they watched on the big screen. They passed it often while traveling around the city. For many, a movie about this special palace is unnecessary.

What more could Boston ask for than to have this theater carefully reconstructed, along with its imaginative exhibits and tributes to vaudeville and the Bijou (another theater that stood on this piece of property in earlier times)? Once again, the famous sign lights up the downtown's theater district.

Moreover, through its reconstruction, it is once more Boston's best example of the Art Deco style of architecture and design. It had gone an entirely different direction from the other palaces. There are, as one publication put it back in 1932, no "vaulted halls, marble staircases and glitter." What is there instead is, in the words of the Boston Landmarks Commission, "a brilliant display of Aztec, Egyptian, and American Indian art forms. Few if any other major buildings in the region offer a better example."

In its 1983 report on why the theater should receive Boston Landmark status, the commission spoke of not only its significance to entertainment history but also to the architectural and cultural history of the city, the Commonwealth, and New England.

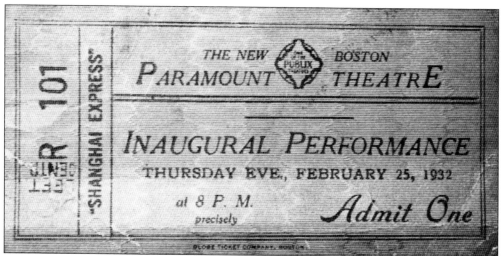

OPENING NIGHT TICKET. On a chilly winter's evening in 1932, over 1,500 filmgoers got their first glimpse of the Paramount. The Publix Theatre division of Paramount Studios built it as the first theater in downtown Boston that was designed exclusively for full-length talking film exhibitions. Its purpose was to provide a new exclusive first-run outlet for the films Paramount was churning out at the time. (Courtesy of Emerson College.)

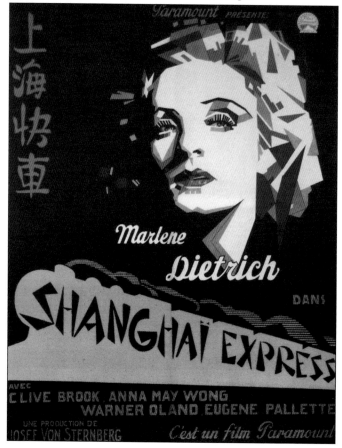

POSTER OF FEATURED ATTRACTION. A close look discloses that this poster was designed for French audiences, but little is lost in the translation. It was rumored that the film's star Marlene Dietrich would attend, arriving by helicopter on nearby Boston Common. It never happened and opening-nighters settled for studio and city officials. (Courtesy of Emerson College.)

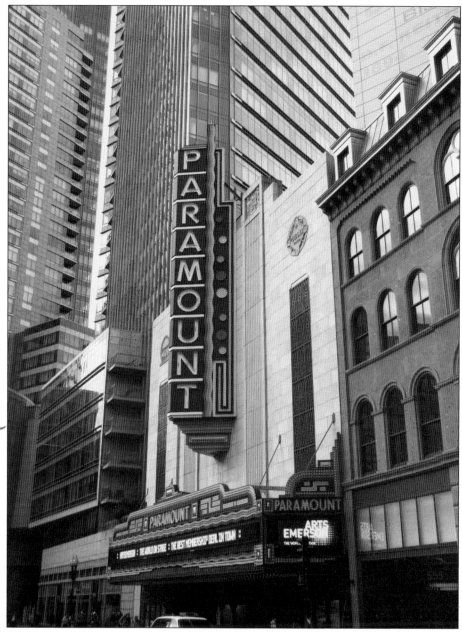

THE PARAMOUNT'S FAMOUS MARQUEE AND BLADE SIGN. The marquee changed weekly as Paramount turned out 60 to 70 films a year, but more significantly, the 60-foot-tall blade sign quickly became a Boston icon. When the theater shuttered in 1976, both were turned off for 26 years. Fortunately, the City of Boston soon became the owner, and though the theater remained vacant, it received Boston Landmark status, protecting it from demolition. On May 14, 2002, the first major step toward restoration involved Mayor Thomas Menino flipping a switch to illuminate the restored marquee and blade sign. Millennium Place, a combination high-rise condominium and hotel opening less than a block away, financed the $1.5 million project, which also repaired the facing and the roof. The event invigorated the community. In time, Emerson College purchased the building to be a part of a new complex.

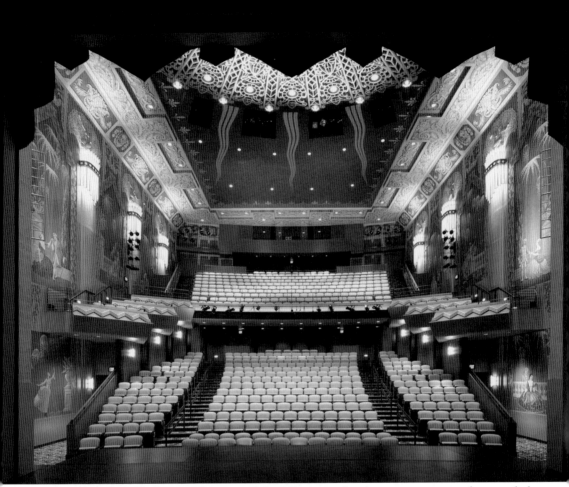

ORCHESTRA AND BALCONY. This view of the fully restored auditorium gives a good sense of what the original 1,500-seat Paramount looked like to filmgoers. It was more intimate than larger Boston palaces, and no matter where a person sat, he or she was assured a good view. Without stage shows, its proscenium was shorter, and viewers were closer to the screen. The theater's acoustics were exceptional, and with talking pictures now in their fourth year of production, sound quality mattered more and more. Dramas were becoming more sophisticated, and comedies were wittier. Viewers did not want to miss a word. For the first time, there were musicals with singers, dancers, and orchestras. Good sound was essential to fully appreciate the work of Paramount's lineup of stars, including Marlene Dietrich, Claudette Colbert, Miriam Hopkins, Mae West, Gary Cooper, Bing Crosby, and the Marx Brothers. (Courtesy of Peter Vanderwarker.)

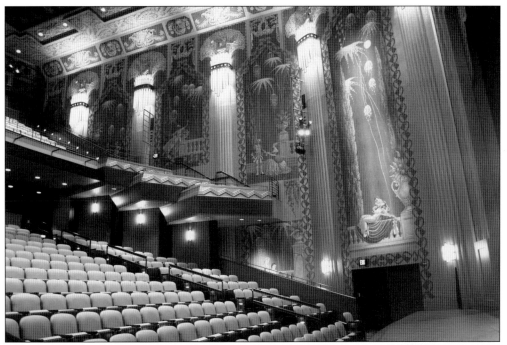

AUDITORIUM ORCHESTRA WALL. As in the original building, both side walls are divided into six bays, each with its own mural. The tall ziggurat light fixtures, an Art Deco specialty, help to define each bay. For the audience, it creates an atmosphere unlike the other palaces, where walls were decorated but not in such innovative ways or with such a variety of color and ornamentation.

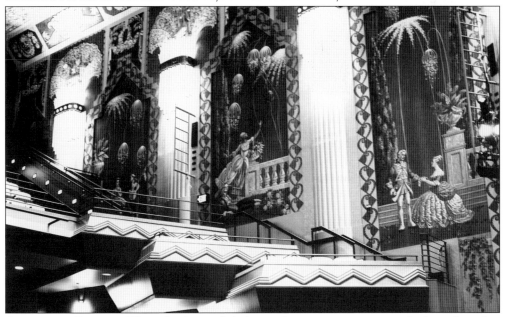

AUDITORIUM BALCONY WALL. In the single balcony, theatergoers were never far from the aisles. Every seat provided a good view not only of the screen but of the artwork as well. Although the size of the auditorium was reduced from 1,657 to 590 seats, Elkus Manfredi Architects recreated much of the design of original architect Arthur Bowditch when the theater was reconstructed.

MURALS UP CLOSE. During the 34 years that the theater was closed, much of the interior was lost, particularly during asbestos removal. Fortunately, prior to that work, the original murals had been removed and stored at Conrad Schmitt Studios in New Berlin, Wisconsin. Though spared, they were too badly damaged for repair. But the company was able to recreate them using stenciling and other special techniques. Romantic figures in the scenes wear costumes from the French and English court tradition of the 17th and 18th centuries, including powdered wigs. Some figures appear in exotic settings, while others appear to be right in the Paramount Theatre's balcony boxes.

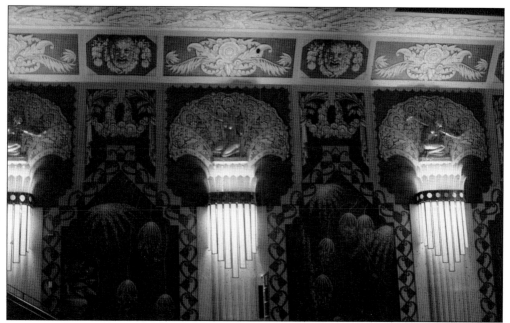

CUSTOM-DESIGNED LIGHT FIXTURES. The theater features Art Deco lighting at its best. Each yellow and green wall fixture, designed to look like chimes, gives off a golden glow. Each is capped by other Art Deco symbols, and in this case, seashells and gold figurines are visible. New York's huge Radio City Music Hall may have more extensive Art Deco lighting, but the Paramount's seems just right for its size.

NO CRYSTAL CHANDELIERS IN THIS PALACE. This was a typical ceiling light. Paramount-Publix was still in a building boom at this point and built several Art Deco theaters throughout the Midwest similar to their Boston Art Deco palace. The style came into fashion in America following Paris's 1925 Exposition Internationale des Arts Décoratifs et Industriels Modernes.

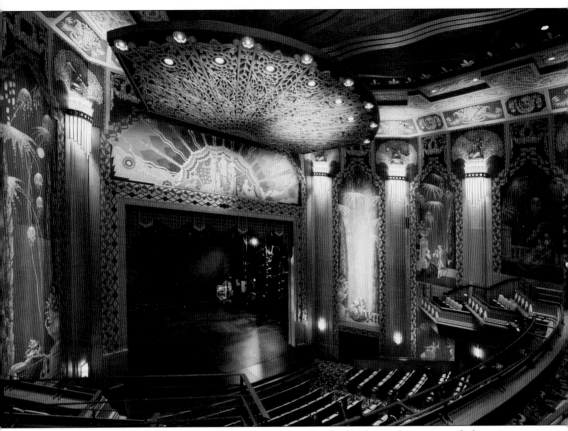

RECONSTRUCTED STAGE. Beginning with an empty shell, the architects needed to reconstruct the theater for a variety of uses, ranging from live stage performances to film. The proscenium opening was moved forward some 34 feet to allow for the creation of a stage, orchestra pit, and fly house, none of which were a part of the original theater. The goal was to create an atmosphere encouraging 21st-century students to interact with the core design of a 19th-century facility. To that end, a visitor from the 1930s would still see the proscenium arch, with its huge mural adapted from artwork observed at Paris's Exposition Internationale and its ceiling fan design. Emerson College is making full use of the theater to present the very best performances in drama, dance, and music for both the public and students.

STAIRWAY RAILING DETAIL. More Art Deco design is apparent in this railing that appears all along the stairway connecting the entrance and balcony lobbies. The carpeting, too, is an authentic recreation of the original design. The second and third levels also contain a black box theater, a large multiuse space for rehearsals, receptions, and extensive wall exhibits.

SECOND-FLOOR LOBBY. Today, the second floor appears much as it did in the 1930s. Working from an old photograph, replicas of the original sofa, table, and lamp for the center of the lobby were created and placed close to their original locations. That kind of attention to detail is apparent throughout the theater.

Tribute to the Bijou and Vaudeville. On the third level, located outside the auditorium, a permanent, giant wall display memorializes thousands of performers who appeared in Boston on stage or screen at the Bijou, vaudeville houses, or elsewhere through the 1920s. Movie greats Ginger Rogers and Charlie Chaplin are featured along with entertainers, such as Kate Smith, Will Rogers, and Sophie Tucker. (Courtesy of Emerson College.)

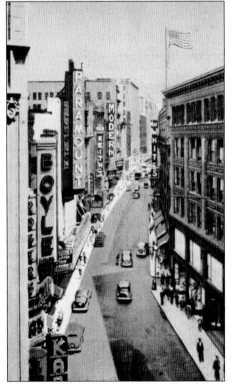

Postcard View of the Paramount and Its Neighbors, 1942. A visitor sends word to a Rhode Island family member that she is "having a swell time" in Boston. Though not visible, the building in the foreground on the right houses the RKO Boston, which was also constructed by architect Arthur Bowditch as the Keith-Albee Boston Theatre in 1925. (Courtesy of Suffolk University.)

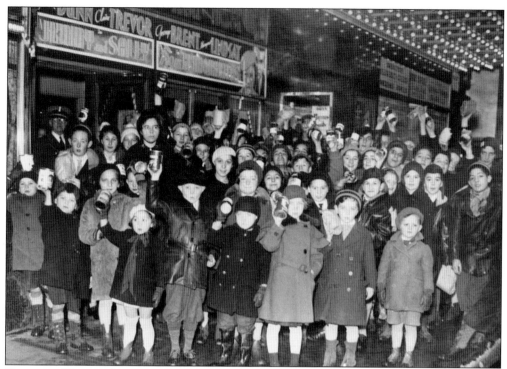

CHEERING NEWS IN HARD TIMES. The Paramount's combination of kids and charity work won photograph space in the *Boston Traveler* sometime during the Depression. The caption reads, "Paying their way with canned goods, boys and girls who wished to see the double feature today crowded into the theater at an early hour and had a wonderful time." The canned goods were sent to area charities for Christmas distribution. (Courtesy of *Boston Herald*.)

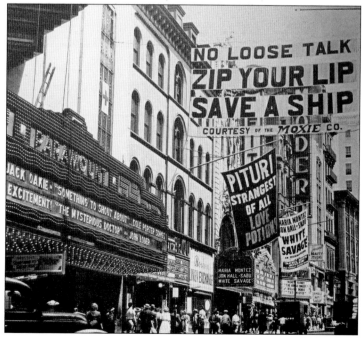

WORLD WAR II BANNER ON WASHINGTON STREET, 1943. Signs like this were a constant reminder of the war to moviegoers and shoppers and the men and women serving. On this day, the Paramount was offering a new Columbia Pictures musical, and the Keith Memorial had its usual banners out, which were for a new Universal Studios adventure film. Just beyond, the Modern had Mickey Rooney in *The Human Comedy*. (Courtesy of Emerson College.)

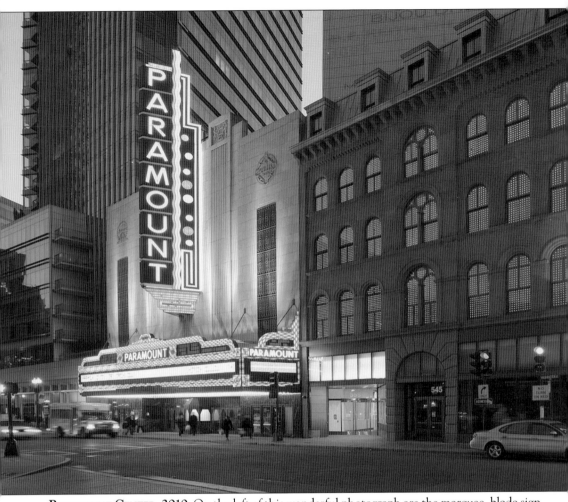

PARAMOUNT CENTER, 2010. On the left of this wonderful photograph are the marquee, blade sign, and facade of the Paramount. The facade on the right belongs to the building that housed the original Bijou. At night, dynamic video art can be seen on a programmable LED installation. On the facade of the new stage house behind the theater, the word "Bijou" can also be seen. This is the scene that welcomes theatergoers as they arrive for performances of ArtsEmerson: The World on Stage. This groundbreaking program provides new opportunities for the Boston community to experience culturally enriching theater, film, and music. ArtsEmerson is committed to bringing many of the world's legendary and pioneering artists to Boston, presenting work from this country and abroad. This scene illustrates some of the best uses of today's technology and creativity in the restoration of a landmark American movie palace. (Courtesy of Peter Vanderwarker.)

Nine

Changing Times, Changing Theaters

After the Paramount opened in 1932, the 50-year boom in Boston theater building came to an end, though it had nothing to do with interest in motion pictures. As the Depression spread, attendance at movie theaters actually increased, though still over half of all Americans were not going to the movies in a given week. Watching Jimmy Cagney or Humphrey Bogart acting in a crime-doesn't-pay thriller, or Fred Astaire and Ginger Rogers tapping away, or the Marx Brothers wreaking their own special kind of hilarious havoc on screen created a great escape from tough times in the 1930s.

And it did not hurt to have the big bands, radio stars, and recording artists on the bills as well. Tickets were cheap, and being downtown with all the lights and crowds and beautiful theaters was great fun.

During World War II, attendance continued to grow. The movies told stories of everyday people caught up in the war, and newsreels provided theatergoers the very latest pictures of the troops overseas.

But when the war ended, things downtown began to change dramatically. Returning service men and women got married, had families, and moved to new developments in the suburbs. Traveling into town became more complicated and expensive.

And then came television. Hollywood did its best to compete, offering more color, 3-D, stereophonic sound, and widescreen formats like Cinemascope and Cinerama. But while the suburban theaters flourished, downtown theatergoing continued to decline. Washington Street theaters changed hands and changed names. Many went dark.

Some cities never recovered. Downtown Boston theaters might have met the same fate had it not been for two related events: the arrival of a risk-taking local businessman turned theater entrepreneur named Ben Sack, who put the lights on at a dozen downtown theaters, and a new Hollywood concept called road show engagements, which helped to raise the quality of movies considerably. From the mid-1950s to 1970, downtown Boston moviegoing had a renaissance. Years later, several palaces and other theaters were saved from the wrecking ball. And, in more recent times, a new mix of film and stage entertainment emerged downtown.

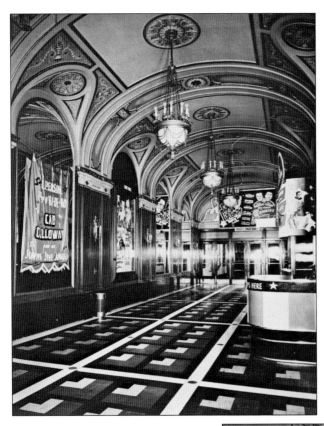

ENTRANCE LOBBY TO A FORGOTTEN PALACE. Originally the Keith-Albee Boston, this 1925 film and vaudeville house designed by Arthur H. Bowditch was the city's third "Boston Theatre." Located at Washington and Essex Streets, it replaced the second Boston theater that was torn down to make way for the Keith Memorial, which opened three years later. The lobby led to the 3,231-seat auditorium. Later renamed the RKO Boston, it continued its winning formula of films and stage shows through the 1940s. It is now used as a warehouse. (Courtesy of THS.)

ORCHESTRA FOYER. Typical of Keith theaters nationwide, there was a sense of luxury here for theatergoers, with no lack of crystal chandeliers, rich carpeting, granite columns, and detailed railings. For a while people came for vaudeville, but the big draw soon became the first-run films featuring many of RKO Radio Pictures biggest stars, like Fred Astaire, Ginger Rogers, the young Katherine Hepburn, Cary Grant, and the Marx Brothers. (Courtesy of THS.)

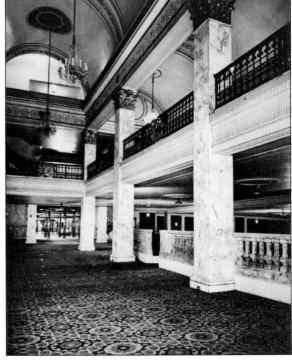

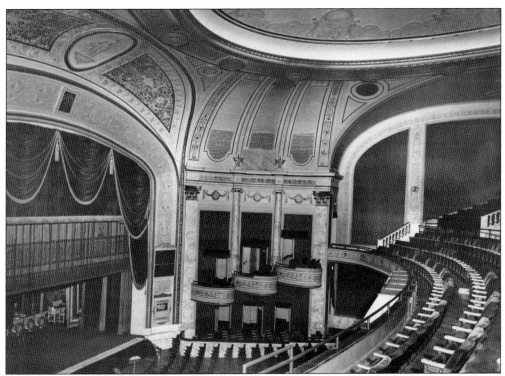

ORIGINAL AUDITORIUM. Loges were still in style and in demand, especially for stage performances. As vaudeville faded, the Boston Theatre began booking big bands, recording stars, and radio comedians. Benny Goodman, Glenn Miller, the Ink Spots, the Andrew Sisters, Abbott and Costello, and Edgar Bergen and Charlie McCarthy all played the Boston Theatre in the 1930s and 1940s. (Courtesy of THS.)

RKO BOSTON NEWSPAPER ADVERTISEMENT, 1945. Continuing to bring glamour and fun to town, this week's program included the newest Earl Carroll review and, of course, a first-run film. When television arrived, with its early televised-live variety shows, like Ed Sullivan's, audiences stopped coming out to theaters for live variety shows. A new life began for the aging theater with the arrival of Cinerama in 1953. (Courtesy of THS.)

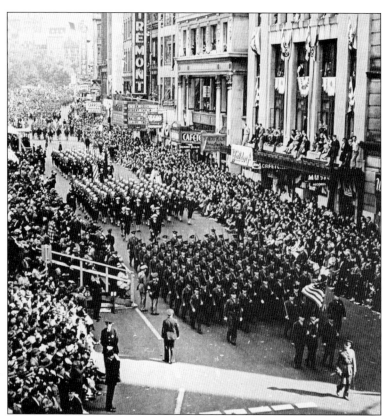

A PARADE PASSING THE TREMONT, C. 1943. Crowds pack Tremont Street for a World War II military parade. Theaters played an important part in the war effort by showing the latest newsreels, showing memorable films with World War II themes, and selling war bonds. Many top film stars would come to town to help in the bond efforts. In the distance, the vertical sign for the RKO Keith Memorial can be seen. (Courtesy of Arthur Singer.)

POPULAR WITH WAITING TRAVELERS. When trains were a more popular mode of transportation, South Station Theatre was a popular place, especially with those serving during the war. This entrance, along with another inside the terminal, led to a small auditorium where one could pass time watching newsreels, shorts subjects, or cartoons. The Lancaster Theatre served train travelers at North Station. (Courtesy of THS.)

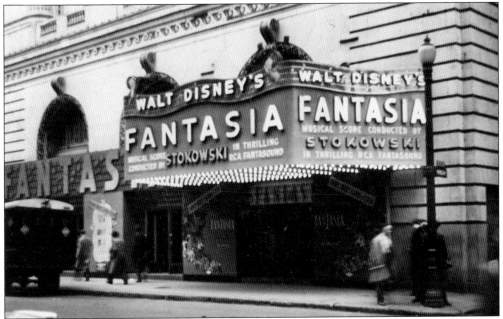

THE PREMIERE OF DISNEY'S *FANTASIA*, 1941. When Walt Disney began looking for a New England theater meeting all of his requirements for *Fantasia*, including enough space for its revolutionary stereophonic sound system, the only one available, which normally operated as legitimate theater, was the Majestic. In later years, Ben Sack bought the theater and converted it to a road show film house. Note the special marquee. (Courtesy of THS.)

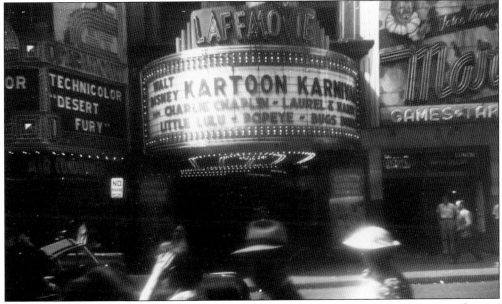

MOVIE PALACE FOR KIDS. Long before cable comedy channels, there was the LaffMovie Theatre. Especially popular in the 1940s and 1950s, children and teenagers would converge on the former B.F. Keith's on Washington Street to experience Laurel and Hardy, the Three Stooges, Abbott and Costello, and other greats. Just inside the entry doors were the beloved Crazy Mirrors that distorted the patron's size or shape. (Courtesy of THS.)

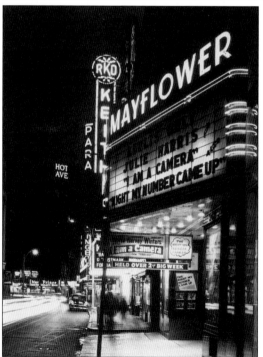

Postwar Change in Scollay Square.
With sailors and other service personnel gone, the square lost many of its customers and its popularity as an entertainment center. All businesses suffered during the 1950s, but none more than its theaters. By the time this photograph was taken, the mighty Olympia had closed, and the Rialto next door was just about surviving. It was only a matter of a few years before all of this would be gone. (Courtesy of MIT.)

Name Changes for Old Favorites. In 1949, the Modern Theatre became part of the new ATC movie chain, which included a number of other downtown and neighborhood theaters in Boston. Renamed the Mayflower, it was regularly advertised, curiously, as "Mayflower (formerly Modern)." The theater could not escape the continued decline of downtown moviegoing in the city. (Courtesy of MIT.)

POSTWAR PROBLEMS FOR THE TRANS-LUX. The 1950s were especially difficult times for independent downtown theaters to compete. This lower Washington Street house, originally the beloved Park Theatre playhouse, had the dubious distinction of being the first to show sex films full-time. Enraged stockholders demanded the name be changed, and it was to the State Theatre.

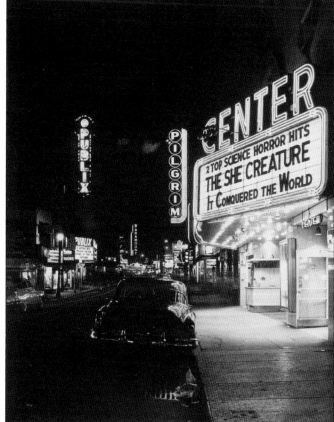

SAME PROBLEMS FOR THE OLD GLOBE. In 1947, the venerable Washington Street Globe, now owned by E.M. Loew, was totally remodeled, renamed the Center, and made the flagship theater of Loew's growing chain. After a brief and unsuccessful attempt to offer stage productions, including an ice show, it settled in as a second-run 1,200-seat movie house. (Courtesy of MIT.)

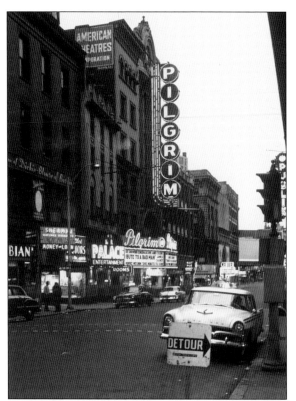

RISE OF THE PILGRIM. The Pilgrim Theatre, formerly the Washington Street Olympia, got off to an innovative start under the American Theatres Corporation, a company formed in the late 1940s. When afternoon theater regulars began frequenting nearby bars to watch live baseball games, the Pilgrim management bought the rights and equipment to show the 1949 World Series on their big film screen, and the house filled again. (Courtesy of MIT.)

FALL OF THE PILGRIM. With box office attendance worsening, Hollywood scrambled to develop new technologies. For example, three-dimensional film allowed viewers wearing special plastic glasses to see movies with depth. The Pilgrim was the first in town to run 3-D shorts. Such features found even larger venues. But it was a fad and did not last, nor did the Pilgrim, as this later image shows. (Courtesy of THS.)

LOW POINT ON WASHINGTON STREET. This image of Washington Street in the 1970s speaks for itself. Empty lots and closed theaters. These were the darkest days for Boston's Broadway, which for a time became known as Boston's Combat Zone. The reasons were many. In the 1960s, a series of US Supreme Court decisions loosened the definition of what constituted pornography. In 1967, film distributors decided that downtown theaters would no longer have exclusive rights to open major films. Drugs and prostitution had migrated here from Scollay Square. Gangs and guns added to the problem. In time, the city contained the area and took action to eliminate these problems. Developers began to show interest. The Boston Preservation Alliance rallied arts groups, elected officials, national theater officials, and others to develop ways to preserve the theaters. Change came slowly but ultimately proved successful. (Courtesy of BPL Print Department.)

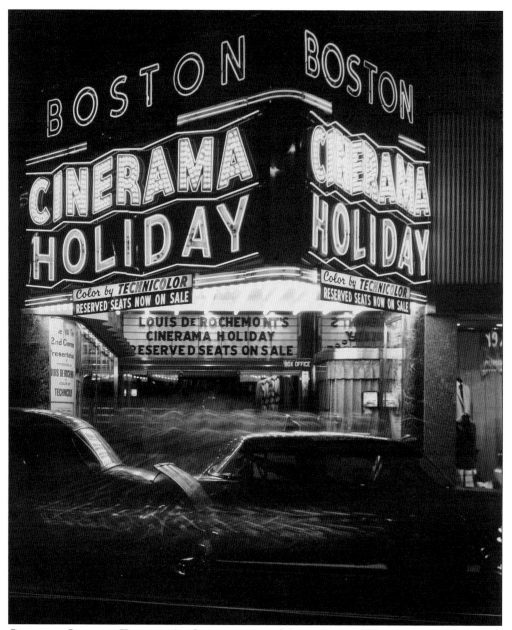

CINERAMA COMES TO TOWN, 1954. One innovation did prove successful and kept people coming to town for a decade. Cinerama Corporation bought the RKO Boston, completely reconstructed the auditorium, and installed a three-projector system that beamed overlapping pictures onto a tall 165-degree screen giving the illusion of depth. Advertisements proclaimed the Boston as the only theater in New England able to show Cinerama films. The first film, *This Is Cinerama*, included a roller coaster sequence filmed with cameras in the first seat. Sellout crowds followed, and the film ran for a year. Here is the signage for the second film in the series. Cinerama films kept the Boston in business for 12 strong years. As author Donald C. King observed, along with Cinemascope, it "changed the shape of the screen forever—the old square picture became a rectangle." (Courtesy of MIT.)

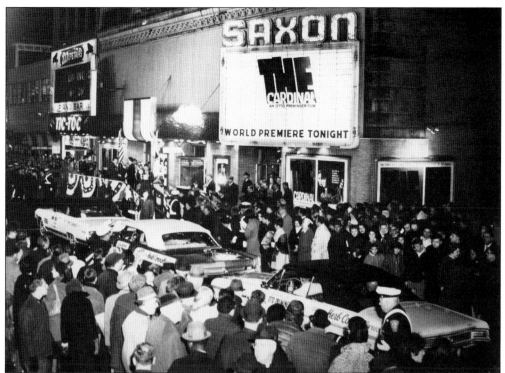

OPENING NIGHT AT THE SAXON, 1963. Meanwhile, businessman Ben Sack had found a formula for success. Sack leased the Majestic in the mid-1950s, changed its name, bid aggressively, and began showing road show films, beginning with *Oklahoma!* and *Around the World in 80 Days.* Here, the Saxon is hosting the world premiere of Otto Preminger's *The Cardinal*, with first-night proceeds going to Catholic Charities of Boston. (Courtesy of *Boston Herald*.)

STARS OF THE FILM CHAT WITH CARDINAL CUSHING. In this photograph, director Otto Preminger (second from the left) and stars Carol Lynley (far left), Romy Schneider (third from the left), and Tom Tryon (second from the right) talk with the Cardinal Cushing about the film just before the screening. Proceeds from opening nights almost always went to a relevant charity, guaranteeing a full house and goodwill for the Sack organization. (Courtesy of Terry Sack.)

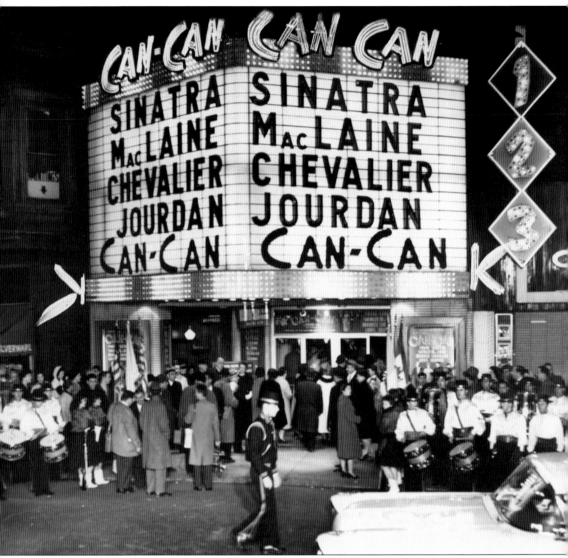

Can Can Opens at the Gary, 1960. Seeking a second big theater for the increasing number of road show films available, Sack again found an underutilized, legitimate theater. In fact, it was right around the corner from the Saxon (Majestic). The Plymouth, built in 1911, was a storied playhouse on Stuart Street right off Tremont Street. Sack leased the theater in 1958, and about the biggest opening expense for the Gary was putting up a new marquee. Equipped with the Todd AO projection system at the Saxon and the Gary, the Sack organization was well positioned to negotiate for the best films. Other films opening here included *Lawrence of Arabia*, *West Side Story*, and *Mary Poppins*. The Gary was demolished in the 1970s to make way for the Massachusetts Transportation Building. (Courtesy of *Boston Herald*.)

BEN HUR OPENING, 1959. Stars Stephen Boyd and Martha Scott are greeted by Barbara and Ben Sack at the New England premiere of William Wyler's epic film. It took effort and ingenuity by Sack executive A. Alan Friedberg to bring in the stars for these events. The movie, which went on to win a record 11 Oscars, is remembered best for its 15-minute chariot race sequence. The Sack organization built these star visits into its contract with the studios. (Courtesy of *Boston Herald*.)

DOCTOR ZHIVAGO PLAYBILL, 1965. Road show films provided souvenir programs for attendees, as did live theater. Reserved seats were required. Film versions of Broadway shows were especially popular, from *My Fair Lady* to *Fiddler on the Roof*. This epic from David Lean, starring Omar Sharif and Julie Christie, ran over three hours. Others were even longer. (Courtesy of Emerson College.)

SACK MUSIC HALL GRAND OPENING, 1962. For leasing the Metropolitan Theatre from the New England Medical Center, whose plans for a new campus might well have closed the theater forever, Sack is considered the man who saved Boston's beloved movie palace. With Washington Street theaters closing all around and concern about crime rising, the Sack investment was seen as a positive sign for the future. The Sack team arranged for a gala event that was more about the theater and downtown than about the particular film. *Boys Night Out* had an all-star cast, including Kim Novak, James Garner, and Tony Randall, but was not a memorable film. For the next decade, the Music Hall drew people of all ages to films, concerts, and special events. (Courtesy of *Boston Herald*.)

STARTING FROM SCRATCH, 1967. After 15 years of rehabilitating old or shuttered theaters, Sack, along with financial partners, built his first new Boston theater. Within a new Back Bay garage at Dalton and Boylston Streets, a block from the Prudential Center, the Cheri boasted a 70-mm film system and easy access for suburban filmgoers. In time, it morphed into a duplex and then into Boston's first triplex. (Courtesy of *Boston Herald*.)

CHERI STAFF TAKE TIME OUT FOR A PHOTOGRAPH. Ushers and others pose for a promotional photograph prior to a nautical-oriented film premiere. Theater manager Tom Kauycheck (back row, left, in tux) began as an usher with the Metropolitan and then spent 38 years working for the Sack organization, managing the Music Hall, Cheri, and Cinema 57. (Courtesy of Tom Kauycheck.)

GROUND BREAKING FOR THE PI ALLEY THEATRE, 1969. Mayor Kevin White turns the shovel as Ben Sack and Samuel P. Coffman look on. The new Washington Street theater was built along with a new Coffman parking garage at the old *Boston Post* location. (Courtesy of *Boston Herald*.)

SACK FORMULA AT WORK. In 1958, Sack was seeking yet another first-run house. Again finding an old, ailing theater, the Copley Square, he renamed it the Capri after leasing and remodeling it. Three years later, it was claimed by Massachusetts to make room for the Massachusetts Turnpike extension. Undaunted, the company leased the nearby E.M. Loew's Strand on Boylston Street near the Prudential Center. (Courtesy of *Boston Herald*.)

DISNEY AND SACK. Most films companies, like Walt Disney Studios, regularly hosted special promotional events in California, bringing in theater executives from around the country. At this meeting, guests were greeted by Disney staff outfitted in special high-button uniforms and pill box hats. Impressed, Sack came back and ordered similar uniforms for his ushers and refreshment stand personnel. (Courtesy of *Boston Herald*.)

CUTLER MAJESTIC THEATRE TODAY. After a storied career as a legitimate theater and film house, the Majestic was purchased in 1983 by Emerson College. Vision, perseverance, and the commitment of $14.8 million over 20 years restored the American Beaux-Arts masterpiece, ensuring the future of the college's performing arts programs and contributing to the theater district's economic rebirth and social vitality. (Courtesy of Emerson College.)

LEGENDARY FILM HOUSE IN CAMBRIDGE.
Housed in Brattle Hall in busy Harvard
Square, Cambridge, the Brattle began
as a home to live theater in 1891. Since
1953, it has been a full-time movie house,
committed to showing classic, foreign,
and art-house films. One of its signature
series is the annual "Bogie" (Humphrey
Bogart) film festival during exam time
at Harvard. The Brattle's name sign and
street-level billboard serve as its marquee.

**REPERTORY FILM SERIES STILL THE
CENTERPIECE.** While the theater hosts
many annual film festivals, including
the Underground and the Boston
Independent festivals, its specialty is
still showcasing directors from Jean-Luc
Godard to Alfred Hitchcock, genres
from great romances to fear on film, and
actors from Astaire to Jack Lemmon. As
one writer put it, "The Brattle inspires a
kind of nostalgia verging on worship."

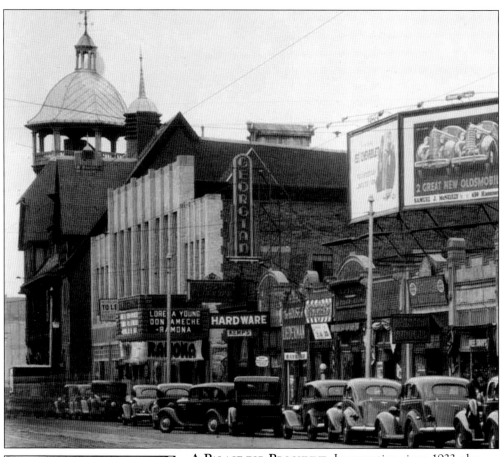

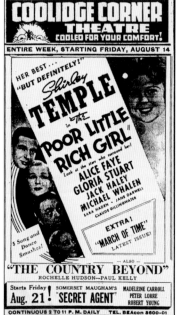

A Palace for Brookline. In operation since 1933, the Coolidge Corner Theatre is the ultimate survivor. Built on Harvard Street near Beacon Street after years of opposition by skeptical residents, one can see it here in 1936. Close to the Beacon Street trolley, it was accessible from most parts of Boston. On the marquee is a romantic drama most notably being one of the first films shown in "new perfect Technicolor." (Courtesy of Coolidge Corner Theatre.)

Shirley Temple Raises Spirits. This 1936 *Brookline Chronicle* advertisement announces a weeklong summer stay for the latest film by the remarkable eight-year-old Depression-era star. For 33¢ a ticket, families not only saw Shirley act, sing, and dance but could also see a newsreel, a cartoon, a second feature, and hear the music of organist J. Leslie Cahill.

COOLIDGE TODAY. Carefully restored to its original Art Deco beauty in 2006, the nonprofit house still has its giant silver screen downstairs along with a smaller one upstairs. Each year, a renowned motion picture artist comes to take part in a weeklong celebration of his or her work. In accepting her 2006 award, Meryl Streep said, "I am grateful there are places like Coolidge." (Courtesy of David Fox, photographer.)

FILM CONTINUES IN SOMERVILLE. Another example of adjusting to the changing times, the Somerville Theatre has been in continuous operation since its opening in 1914. It draws audiences from across Greater Boston with its mix of foreign, classic, and independent films and live concerts. Expanded beyond its original footprint, there are now five theaters. The preserved main theater is still used for first-run films. (Courtesy of THS.)

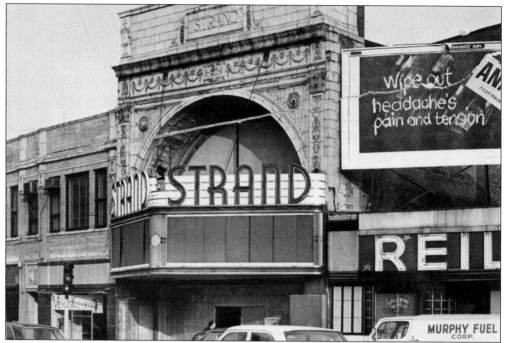

A Dorchester Palace's Storied History. When the Strand opened in Uphams Corner in 1918, vaudeville was still in its heyday. Built for vaudeville and film, the 1,423-seater featured a two-story arched entrance and Adam-style interior. It ran successfully until 1959 and closed completely in 1969. (Courtesy of *Boston Herald*.)

The Rescue of the Strand. In the 1970s, the City of Boston acquired the Strand by eminent domain. Later, Mayor Menino, working with neighborhood leaders, obtained funding to reequip and restore the theater, including this new marquee. Many memorable performances by professional and community groups, along with other civic events, have since been held here. (Courtesy of Don Harney, City of Boston.)

MAYOR'S STATE OF THE CITY ADDRESS. Here, Mayor Menino is about to deliver his 2008 annual address to a large gathering of officials and the public at this historic and revitalized suburban palace. (Courtesy of Don Harney, City of Boston.)

STILL PLAYING IN NEWTON. Opened in 1937, the West Newton Cinema has been in continuous operation ever since. Once part of the M&P Theatres group of several dozen outlets throughout the Boston suburbs, it has survived the television era, floods, and general deterioration, and now operates as a first-run art film house with special children's shows on weekends. Converted into a six-screen complex in 1990, its art deco features are still visible in the lobby and upper level entrances.

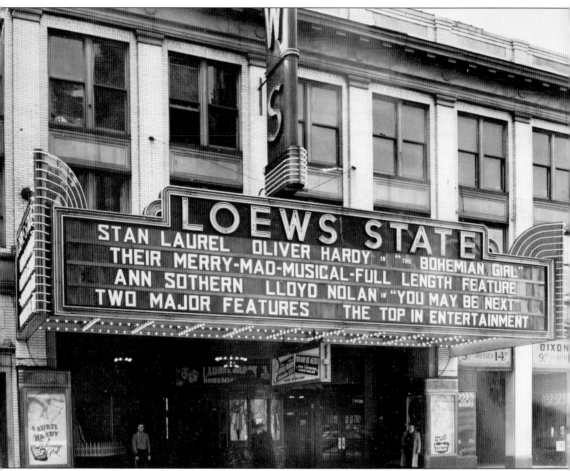

MARQUEE MEMORIES. This 1936 marquee may not be heralding a memorable double bill, but for movie lovers, seeing the names of any actors and actresses can always spark conversation, even today. Who would not enjoy walking into the old Loew's State right now and seeing Laurel and Hardy—just for the fun of it? (Courtesy of THS.)

THEATRE HISTORICAL SOCIETY OF AMERICA

Boston has had a rich inventory of theaters. Images in this book credited as THS are from the Theatre Historical Society of America. Its American Theatre Architecture Archive has information on 15,000 theaters, and there are some 70,000 photographic images of theaters from all over the United States, with many from Boston. These range from Colonial playhouses to Victorian opera houses and from movie palaces of the 1920s to cinemas of the 1930s and multiplexes of today.

Specific THS collections used in this volume include the Terry Helgesen Collection (a former vaudeville pianist who sought theater images while touring), the Richard Hay RKO Collection (bought at auction by Hay, who is with the Oregon Shakespeare Festival, and donated by him to THS), the Michael R. Miller Collection (the late New York lawyer who gave 8,600 of his photographs), the Loew's Collection (specifically, the MGM Theatre reports from 1941 that include snapshots of venues, such as the Kenmore and LaffMovie), and the Ben M. Hall Collection (a vast treasure trove of images and objects assembled by the founder of THS).

THS was founded in 1969 when Hall solicited interest from people with whom he had corresponded while writing him about his book on movie palaces, *The Best Remaining Seats*. Of those folks he contacted, 80 responded, and THS was on its way. Ben M. Hall was a collector who had ferreted out treasures from the New York Roxy (which he had watched disappear from his 25th-floor office window) and from the Loew's Corporation.

In addition to the archive, THS operates the American Movie Palace Museum at its national headquarters in the renovated York Theatre in Elmhurst, Illinois, in suburban Chicago. Objects from the collections are showcased in permanent and changing displays. The museum and archive are open to the public.

Many of the holdings in the archive are used in its quarterly journal, *Marquee*, and in its expanded *Annual* publication.

THS is a nonprofit membership organization. Membership information, information on research in the archive, and lots more are available at its website (www.historictheatres.org).

www.arcadiapublishing.com

Discover books about the town where you grew up, the cities where your friends and families live, the town where your parents met, or even that retirement spot you've been dreaming about. Our Web site provides history lovers with exclusive deals, advanced notification about new titles, e-mail alerts of author events, and much more.

MADE IN THE

Arcadia Publishing, the leading local history publisher in the United States, is committed to making history accessible and meaningful through publishing books that celebrate and preserve the heritage of America's people and places. Consistent with our mission to preserve history on a local level, this book was printed in South Carolina on American-made paper and manufactured entirely in the United States.

This book carries the accredited Forest Stewardship Council (FSC) label and is printed on 100 percent FSC-certified paper. Products carrying the FSC label are independently certified to assure consumers that they come from forests that are managed to meet the social, economic, and ecological needs of present and future generations.

FSC
Mixed Sources
Product group from well-managed
forests and other controlled sources

Cert no. SW-COC-001530
www.fsc.org
© 1996 Forest Stewardship Council

Find Your Place in History.